HAUNTED
NORTH GEORGIA

HAUNTED NORTH GEORGIA

JIM MILES

Published by Haunted America
A Division of The History Press
Charleston, SC
www.historypress.net

Copyright © 2017 by Jim Miles
All rights reserved

First published 2017

Manufactured in the United States

ISBN 9781625859471

Library of Congress Control Number: 2017940925

Notice: The information in this book is true and complete to the best of our knowledge. It is offered without guarantee on the part of the author or The History Press. The author and The History Press disclaim all liability in connection with the use of this book.

All rights reserved. No part of this book may be reproduced or transmitted in any form whatsoever without prior written permission from the publisher except in the case of brief quotations embodied in critical articles and reviews.

To Alabama, my home state, for teaching me to love reading and writing and instilling in me a lifelong passion for history and all things weird.

CONTENTS

Introduction	9
Banks County: The Haunted Frontier Fort	11
Barrow County: What Is Scarier, the Ghosts or the People?	14
Bartow County: Barnsley Speaks from the Grave	17
Campbell County: Florence Remains	21
Carroll County: The Restaurant Ghosts	25
Catoosa County: Do You Want to Come Out and Play?	29
Chattooga County: Murder at Corpsewood	31
Cherokee County: The Toilet Paper Nazi	37
Clarke County: Ghosts in the Outhouse	39
Clayton County: All the Ghostly News that's Fit to Print	41
Cobb County: "Mary, Mary, Why Did Your Babies Die?"	43
Coweta County: Ghostly Angels…or Angelic Ghosts?	46
Dade County: An Order of Ghosts to Stay	48
Dawson County: Native American Spirits Inhabit Resorts	51
DeKalb County: The County Ghost House	54
Douglas County: The Ghost Photographs of Chester Heath	58
Elbert County: Ghosts in the Textile Mill	60
Fannin County: A Ghost Played "Sourwood Mountain"	63
Fayette County: Is a "Doc" Holliday in the House?	66
Floyd County: Blame It on George	69
Forsyth County: Dead Tales Told in School	72

Contents

Franklin County: The Southern Oaks Ghosts	75
Fulton County: The Pink Lady	79
Gilmer County: The Black Vehicle, a Mountain Urban Legend	82
Gordon County: Tinkerbell on the Battlefield	85
Gwinnett County: The Locomotive and the Giant Ghost	88
Habersham County: Ancient Ghosts	89
Hall County: The Library Ghost that Answers the Phone	92
Haralson County: Pre-Occupancy Investigation	95
Hart County: Antics of a Female Spirit	97
Henry County: Our Upstairs Neighbors	100
Jackson County: Little John Haunts City Hall	102
Lincoln County: The Ghost on the Stairs	105
Lumpkin County: The Photogenic Cemetery Ghosts	106
Madison County: The Ghost in the Blue Pickup Truck	109
Milton County: The Ghost of an Extinct County	111
Morgan County: You Can't Sleep in the Haunted Bedroom	113
Murray County: The Horrifying House	116
Oconee County: The Children Remain	119
Oglethorpe County: Father Visits from the Front	121
Paulding County: The Ghost of the Murdered Murderer	122
Pickens County: Premonition of a Tragedy	124
Polk County: Native American Guardian	126
Rabun County: The Ghost of Tallulah Falls	128
Rockdale County: CGPS Case #112108	130
Stephens County: A Band of Ghostly Brothers	131
Towns County: The Friendly Ghost on Frog Pond Road	134
Union County: The Spirits at Track Rock Gap	136
Walker County: Haunted Lookout Mountain	138
Walton County: Have You Seen "Her"?	140
White County: The Nacoochee Valley Ghost	143
Whitfield County: The Wink, a Haunted Theater	146
Wilkes County: A Hunting Camp Story	150
Bibliography	153
About the Author	157

INTRODUCTION

I have been gathering materials about paranormal Georgia since my teenage years, and that was some time ago. Over the past ten years, I have labored on a daunting project: to collect a ghost story from each of Georgia's existing 159 counties, plus two counties that went bankrupt during the Great Depression. My wife, Earline, and I crisscrossed this huge state to record ghostly encounters firsthand, search hundreds of old vertical files at libraries and scour two hundred years of Georgia newspapers and magazines, as well as every book relating to Georgia.

For these books—*Haunted North Georgia*, *Haunted Central Georgia* and *Haunted South Georgia*—I have found stories dating from the present back to prehistoric times, always looking for unique stories with unusual details and largely avoiding the more common ghost tales. Some of the longest stories are from the least-known and least-populated Georgia counties, while several of the shortest originated in the crowded counties around the big cities. These books are about all of Georgia, from rural to metropolitan. Think of this as state folklore, from the remotest past of Georgia to the present.

These books will appeal to those intrigued by the supernatural and to anyone who embraces the entire Georgia experience and desires to learn a piece of folklore from each of our many small counties. Readers will learn that ghost tales are universal, varying little between regions, centuries and cultures.

My long manuscript has been divided into three books, organized geographically. Georgia is generally divided into three regions. North

Introduction

Georgia is the mountains; Central Georgia is the piedmont and fall line, which connects the cities of Columbus, Macon and Augusta; and South Georgia is the coastal plain, including Savannah and the coast. These regions are geographic in nature, but here we pull North Georgia down to include Metro Atlanta and Central Georgia is extended farther south simply because the coastal plain is so large. Each book contains roughly equal numbers of counties.

As you read, consider Georgia as one large community rather than as isolated parts. During your next break, head for a region that you aren't familiar with and get better acquainted with our people.

Banks County

THE HAUNTED FRONTIER FORT

Fort Hollingsworth was constructed in 1793 as a blockhouse for protection against attacks by Native Americans. It was purchased before the Civil War by John Lane, whose family stills owns the structure. Sisters Willette Mote and Edith Goodson, two of eight children in the last generation to dwell in the house, published *White Tales from Hollingsworth*, a history of family life in the White House, the post–Indian Wars name for the structure.

Goodson and Mote wrote that any relative could relate several ghostly stories. Many people have reported the sounds of a table being set in the kitchen, and as silverware and plates were being audibly laid on the table in the empty kitchen, voices have often been heard, sounding like they were issuing from a television or radio. However, the voices instantly vanished when someone stepped up to the porch and grasped the doorknob.

A frequent manifestation experienced by many over the decades has been labeled the "Big Boom," described "as if a large empty wooden barrel is being dropped from the attic," the sisters wrote.

In the dim family past, their mother invited her eight sisters to an all-night party. The nine ladies talked and laughed and ate until the wee hours, but finally they all lay down on beds, the couch and pallets on the floor. A haint took advantage of the quiet to launch a "Big Boom," which they interpreted as a warning not to disturb its peace again. The sisters dispersed and did not assemble en masse again.

The family kept a large chest freezer in the kitchen, and occasionally Mellie, one of the children, would enter the kitchen, pull the chain to turn

White House is a frontier blockhouse called Fort Hollingsworth. Its loud audio ghost frequently vexed residents. *Jim Miles.*

on the overhead light and open the lid. As she looked inside the freezer, the light would click off. She would reactivate the light, but it flicked off again, according to Jeannette Jacobs in the April 2002 issue of *Athens* magazine. Of the ghost, Mellie told her husband, "I'll live here and I'll hear things, but the first thing I see, I'm gone."

The kitchen, which was in the oldest part of the house, was the most popular space with the ghost. When no family member was near the kitchen, they would hear a sound like the breaking of all their china. Investigation found nothing harmed. A normal activity in homes in the past was propping windows open with sticks for ventilation. In the White House, sounds like a window falling shut and breaking with great force was heard, but inspection found no problems with any window.

One day, Edith and a nephew, Stacey, were cleaning the sitting area; as they finished the sweeping, the boom issued with such force that they thought the chimney had exploded. They jumped back and waited for the windows to fall out of their frames as the walls shook from the concussion. A check of the house found nothing amiss. Goodson and Mote believed that the explosive noise was the cannon blast that had killed family member John Lane during the Civil War.

One common manifestation was phantom footsteps, which always walked hard and fast. One cold afternoon, Edith and her mother, Mellie, were eating vegetable soup and cornbread when they heard footsteps on the porch approaching the kitchen door. They watched intently as the doorknob turned, but nobody entered. "Come on in," they called, and the knob continued to turn; still no one entered. "Come in," they repeated, but no person ever did. The women opened the door to find no one present and the screen locked.

Mama moved in with her son Dan, who lived next door to the White House. Dan's brother, Denver, was deaf and attended the Georgia School for the Deaf in Cave Spring, and when he returned for visits, he slept in the old house. One night, a vigorous shaking of his shoulder roused him from sleep, much as his father had once done. As he struggled to wake up, Denver saw "the curtains beside his bed blowing wildly but the window was closed. He looked out the window to see a strange looking figure in a stove pipe hat and a dark coat." Denver was so frightened that he fled the house without his pants.

The White House, now listed in the National Register of Historic Places, is preserved in its 1860 appearance by Friends of Fort Hollingsworth. It is located at 2307 Wynn Lake Road, off U.S. 441 near Alto. To arrange a tour, call (706) 776-2419 or (706) 754-4538, e-mail fort@forthollingsworth-whitehouse.com or write to Friends of the Fort, 660 Bethel Temple Road, Demorest, Georgia, 30535. Copies of the book *White Tales from Hollingsworth* are available.

Barrow County

WHAT IS SCARIER, THE GHOSTS OR THE PEOPLE?

The Barrow County Paranormal Society (BCPS) has some good investigative work in its area and written detailed, comprehensible accounts, which is often a rarity in phenomenon research. This is a summary of case #02-001.

On March 4, 2007, the BCPS was contacted by a family in Auburn who had rented a home, constructed in 1961, for only a few weeks and were alarmed by paranormal activity. Their nineteen-month-old son was speaking with a non-visible personality, doors were closing for no discernable reason, two German shepherd puppies acted strangely and the husband often awoke at 1:30 a.m. to music and voices emanating from the living room. When he entered that room, the sounds always ceased.

The BCPS investigated on the night of March 18, employing night-vision cameras, voice recorders, EMF detectors and thermometers. "All persons present felt as if they were being followed by an unseen force, and all of us felt like we were being watched," the team leader noted. One member felt a cool breeze brush past her in the living room, and at 1:30 a.m., all left the home to monitor developments in that room. The entire team heard music and incomprehensible voices, but cameras and voice recorders placed in the living room captured nothing. The team heard a cabinet door shut in the kitchen, and an EVP from there sounded, "Help me," in the voice of a small child.

The results of the investigation induced the family to request a follow-up effort. The BCPS returned on May 5 with a member described as being "sensitive of paranormal activity." That person frequently reported

feeling cold, although others were comfortable in the seventy-degree room temperature. Thermometers registered a number of cold spots, eight to ten degrees lower than the surrounding air, and the leader felt "the cold spot around [a] member that felt like a small static discharge when touched." As an EMF spiked, one member saw a dark figure standing behind the team leader as a digital voice recorder captured a voice saying, "He's found us." At one point, the leader felt "as if something was pushing down on me."

An update to that case was labeled "a strange twist…a little farfetched and hard to believe." As the BCPS reviewed the recordings, the members noted the voice of a young girl say, "Go check the well." The family naturally became concerned about the well, and they said that paranormal activity had increased since the investigation. Several different times, they had been awakened by their bed covers being tugged.

The family requested that a medium investigate their home, accompanied by the team leader. On June 29, two mediums and the leader arrived. The mediums knew only that unexplained events had been experienced in the house.

One medium detected a presence in the hall where "He's found us" had been recorded. A nineteen-month-old resident took one medium by the hand and led both to the hallway, where the sensitives experienced the presence of an eight-year-old girl. They believed her first name had been Darla, and her last name perhaps was Washington. In the 1880s, she had witnessed her grandfather's murder on the property. The leader felt a heavy feeling, and the voice recorder registered several anomalies. Later, he discovered a child's voice answering the questions asked by the mediums, information that the psychic had relayed at the time.

In one bedroom, which was usually ten to fifteen degrees colder than the remainder of the house, a medium detected Native American spirits and felt that something was beneath the floor. The family revealed that an ancient burial mound and a cave with petroglyphs were located in the woods across the street. Audio recorders revealed a man's voice speaking in an unknown language.

In the living room, the mediums felt as if they were being drawn down into the floor. This was the space with the voices and music and cool breezes.

One medium was drawn to the well house in the yard and opened the door, which drew a reaction from the other psychic, who crossed her arms and backed away. A rotten smell emanated from the structure, which made the leader sick to his stomach but was undetectable to the family. The second medium said, "Oh, someone has died in there." She had "the

feeling of being gagged and bound." The first medium detected a presence within the well.

The investigators had brought an underwater camera with night-vision capability and sixty-five feet of cord. The well was thirty-five feet deep, with the water being only a few inches in depth. The camera image recorded what "appeared to look like a face looking back." A piece of cloth floating on the water was snagged with a hook on a fishing pole and turned out to be twenty inches long and three inches wide, with lace on the edges. They also saw what seemed to be an old crutch but were unable to retrieve it.

During the investigation that night, at 1:45 a.m., a plastic chair shifted half an inch, an act witnessed by two investigators. A doll left in front of a camera was also moved two inches, and an EVP recorded, "I slid the doll" in response to a question.

The team leader advised the family to report their findings to the sheriff and the property owner, but they only informed the owner. The next day, the team leader was present when the property owner and his wife arrived. "You had no business opening that well!" the owner yelled. "There's no body at the bottom of that well! That well has been sealed for forty years, and there's nothing down there!"

"There's no such thing as ghosts!" his wife waded in. "When you're dead, you're dead! There's no body at the bottom of the well!" The team leader was ordered off the property.

On July 7, the owner and a team of men appeared with machinery and drained the well, claiming to have found only mud and muddy water. The family was evicted. The leader reported his story to the Barrow County Sheriff's Office but was told that the case had been dropped due to lack of evidence.

BARTOW COUNTY

BARNSLEY SPEAKS FROM THE GRAVE

In 1941, Colonel Thomas Spencer was a well-known Atlanta historian. He wrote a weekly column for several newspapers, and the week before the Japanese attacked Pearl Harbor, he not only warned of a surprise attack on Hawaii but also named the day: December 7. "All but one of the editors considered it so improbable that they cut it out," he told Katherine Pierce for the December 2, 1950 edition of the *Atlanta Journal Sunday Magazine*.

When the attack was over, America's Pacific fleet had been devastated. More than 3,568 servicemen were killed, wounded or missing; 12 warships had been sunk or beached; and 164 planes had been destroyed, with 159 damaged. Where had Colonel Spencer received his intelligence? Perhaps from a famous Bartow County ghost.

I have written of Barnsley Gardens extensively. Its Civil War history is described in *Fields of Glory* and *Civil War Sites in Georgia*, and the many ghost stories are detailed in *Weird Georgia* (Sterling Press, 2006) and *Civil War Ghosts of North Georgia*, so I will only briefly recap the story.

Godfrey Barnsley emigrated from Great Britain to Savannah and made a fortune in cotton and shipping. In 1840, he purchased 3,600 acres in North Georgia and set about constructing a grand brick Italianate mansion called Woodlands for his beloved wife, Julia. The house would have twenty-eight rooms, hot and cold running water, flush toilets, materials from England and Italy and plants from around the world filling its celebrated gardens.

Unfortunately, Julia died in 1844, and two of their children also died. Godfrey invested his entire fortune in the Confederacy and ended the war

Barnsley's Gardens is one of Georgia's most haunted sites. The landscaped gardens feature strolling spirits. *Jim Miles.*

financially ruined. In May 1864, Union general William T. Sherman's army passed through, looting and destroying exquisite personal possessions and works of art. Two sons who had fought for the South refused to remain and immigrated to Brazil.

After Godfrey died in 1873, land had to be sold to satisfy the debts. In 1906, a tornado destroyed the roof of Woodlands, forcing the family to live in one undamaged wing, where they remained until the 1940s.

On the Sunday before Pearl Harbor, Thomas Spencer visited Barnsley Gardens, known then as the "ruined castle," to see the mistress of the house, Mrs. Addie Baltzelle Saylor, whose grandfather Godfrey Barnsley constructed the house. Mrs. Saylor firmly believed in her family ghosts and had firsthand experience with them. She had seen Grandmother Julia walk outside the library window, and every afternoon, she heard her grandfather conclude the day as he had each day in life: pushing back his chair and walking across the library floor. She heard her spectral aunts and uncles as happy children, laughing and talking, and also detected phantom carpenters continuing their never completed labor on the ruins of the castle.

Mrs. Saylor's generation had its share of tragedy. Her son Harry was murdered by his brother Preston in the remaining wing. Harry first appeared

Visitors to the covered bridge at Euharlee report seeing a young girl hanging from the structure. *Jim Miles*.

One of the fiercest battles of the Civil War occurred at Allatoona Pass, fueling numerous encounters with spectral soldiers. *Earline Miles*.

to her the day after his death and frequently returned to visit with her. It was Harry who had never believed in ghosts.

Mrs. Saylor, according to Colonel Spencer, "told me, 'Harry came last night and said for me to tell President Roosevelt that the Japs are going to attack in the Hawaiian Islands next Sunday.'"

Spencer continued: "Harry had asked his mother, she said, to wire President Roosevelt, and we discussed whether we should do that or not. But you know how far such a wire would have got—and she decided not to."

Ironically, the colonel never believed in ghosts, before or after Pearl Harbor. Mrs. Saylor lived in her home until her death. In 1988, Barnsley Gardens was purchased by investors and turned into a resort. The ruins of Woodlands have been stabilized, and a plank floor allows visitors to imagine its former grandeur. The gardens have been restored, and the original wing contains a museum of the property. Bloodstains from the fratricide are preserved.

CAMPBELL COUNTY

FLORENCE REMAINS

Georgia is famous for the number and small size of its counties. We have 159; the only state with more is Texas. There were once 161 counties, but Campbell and Milton did not survive the Great Depression and were annexed by Fulton County. Some residents of those areas long for their lost counties. For this book, I decided to include ghosts for each of our phantom counties.

In southern Fulton County is Union City, home of the Green Manor Restaurant (6400 Westbrooke Street), originally the site of a house constructed in the early 1800s. The building may have been a Civil War hospital, and legend has several Federals being hanged from a banister, but that seems unlikely. Cannonballs have been found on the grounds.

In 1889, Drewry A. Carmichael arrived, wooed and wed Cora Westbrook, whose wealthy family gave them a house and thirty acres of land. Carmichael and a brother designed farm equipment and started a factory to manufacture their machinery. In 1910, Carmichael razed the house and constructed Green Manor on its foundation. The house, with ten fireplaces, is solid brick, with a granite porch encircling the house and two large columns out front and smaller ones along the porch. The floors are wide, white pine boards.

During a financial panic, Carmichael lost everything, selling the house in 1917 to Dr. Albert J. Green and his wife, Johnnie Hobgood. Green saw patients in a front room, while patients waited in swings and rocking chairs on the big porch.

In 1947, Mrs. Green opened a restaurant, which she operated until her death in 1984 at age eighty-nine. A surviving son operated the establishment, and a manager believed that it is haunted by three ghosts.

One apparent ghost is Mrs. Green, who seems to still occupy her old office, keeping an eye on operations. On occasion, her unique perfume has been detected. Author Christina A. Barber, in *Spirits of Georgia's Southern Crescent*, felt "a distinct chill" while visiting the office. One day, when Green's sons came to dine, a powerful gust of wind greeted them, moving a chandelier and blowing open a rear door. The men felt the presence of their mother.

Another ghost is thought to be Florence Westbrook, sister of Cora and nanny to the Carmichaels' four children. An independent woman for the age, she tragically burned to death in 1914 when the cotton fields were burned off. She is buried nearby at Shadnor Baptist Church.

Florence occupies what is now the bride's room; she makes appearances there and on a balcony. A neighbor who was also a local reporter was passing one night when he spotted Florence walking briskly back and forth on the balcony before abruptly vanishing.

In 1996, a police officer spotted Florence peering out of her bedroom window, an image that still spooks him. Because his radio malfunctioned,

The Green Manor Restaurant has a number of family ghosts that seem to monitor activity at the establishment. *Earline Miles*.

a second officer was dispatched. His radio also mysteriously failed to work, and a third policeman was sent. All three observed the female apparition. Fire department personnel reported seeing lights on in the structure at night, and alarms have been triggered without apparent cause at Green Manor.

In the ladies' room, women checking their hair in the mirror often spot Florence standing behind them. One witness whirled around three times, seeing the mirror image thrice but finding no one behind her.

"Florence shows up in wedding photos all the time," manager and CEO Linda Johnson told Barber. On her wedding day, a nervous bride was calmed by a ghostly presence in the room. Paranormal investigators have heard, at close range, and taped a woman loudly sighing.

A final entity, a man, perhaps a Civil War casualty, is the third spirit at Green Manor. One ghost hunter captured an EVP that declared, "My name is not Florence."

For the October 26, 1995 issue of the *Atlanta Journal Constitution*, reporter Dennis Grogan toured Green Manor. "It's like someone else living in the house," said owner Barbara Green, whose father-in-law was Dr. Green. Soon after Florence died, she said that "strange things began to happen." A sister-in-law of Dr. Green's visited the restaurant one day and nearly fainted dead away, gasping, "My god, that is Florence Westbrook" coming down the stairs from the second floor.

Water faucets, hard to turn on during the day, are found running in the dead of night. Unseen conversations have been heard, and locked doors are found swinging open with no response from burglar alarms. Cocktail glasses have spontaneously shattered, a power line fell on a calm night and one waitress was so frightened that she ran off "and never came back," said chef Richard Hilley.

Green had never believed in the supernatural, "but after a while….I've seen a lot of things move around." Most memorable was a ten-pound angel statue that fell from a mantel six feet to the floor without suffering any damage. "We like her," Green said, adding that many customers request tours of the restaurant in search of a personal sighting of Florence.

In January 2007, *Atlanta Journal Constitution* reporter Christian Boone accompanied investigators from the West Georgia Paranormal Research Society to investigate Green Manor. "She's very evident in the house," said Linda Johnson. She has had several experiences with Florence, as had many staff.

"One time we put some new drapery treatments in her room. She pitched a fit. You could hear her pacing upstairs, and you could see her on the porch

outside." Many people have heard the phantom footsteps on the stairs and on the second floor.

New employees are told that they might encounter Florence, but if so, they were instructed, "Just ignore her; she won't bother you. She's a friendly ghost." Some workers hesitate to venture upstairs to Florence's territory.

After an hour of investigation, the three ghost hunters hurried downstairs, with one stating, "We saw something up there. I'm sort of freaked out." They had apparently been touched by phantoms and saw shadows.

The Green Manor Restaurant serves a buffet lunch Monday through Friday, is open Friday evenings, has a Sunday buffet and can be rented for weddings. The Green Manor Restaurant (http://www.greenmanor.biz) is at 6400 Westbrook Street, Union City, Georgia, 30291. It can be reached at (770) 964-4343 or by fax at (770) 964-2074.

CARROLL COUNTY

THE RESTAURANT GHOSTS

Appleton and Mary Mandeville purchased property on Maple Street in Carrollton and planted maple trees from their native Vermont. A son, Leroy Clifton (L.C.) Mandeville, born in 1856, became an industrial giant, owning extensive cotton fields, a textile mill, a bank and a hotel. Clifton was a generous philanthropist who donated land for and helped establish West Georgia College, serving as a trustee for it and two other Georgia schools.

L.C. Mandeville started construction on what became known simply as the Mansion in 1889. It was completed five years later at a cost of $20,000. The twelve-thousand-square-foot house is three stories tall and made of heart pine timber and had a large copper vat under the roof to collect rainwater to supply the house. It was the first structure in Carrolton to have indoor plumbing, electricity and a telephone.

Decades later, in 1974, the Mansion became a restaurant under a succession of owners. It closed for a while but returned as Maple Street Mansion, catering particularly to students from the university. It has closed again.

The ghost reports started in the early 1970s, when owner Sid Short slept in a bedroom where paranormal activity seemed concentrated. "He was sleeping on the third floor one night," Bob Uglum (who along with his wife operated the facility in the mid-1980s) told *Times-Georgian* reporter Frank Pritchett at Halloween 1988. He "had just gone into his bedroom and shut and locked the door behind him when a young lady in a long white dress walked right through his door, walked round his room, looked around and walked right out through the door."

As Uglum walked into his office one morning, he heard a noise. "So I turn around expecting to see someone behind me, but there was nothing," he told the *West Georgian*, the newspaper of the University of West Georgia, on October 29, 2009. Later, Uglum felt someone breathing on his neck. "Of course I get a little freaked out by this," he said. "But I am also thinking I am crazy. There is nothing breathing on my neck. Well, sure enough, when I looked up there was no one in the room but me."

In about 2007, a couple eating at the Mansion observed a small girl in a white dress stroll across the dining room and gaze out the window. "After that, the couple said she just disappeared," Uglum stated. "I have never seen someone as scared as that couple was."

Ghost stories frequently have a romantic version, and in this case, the spirit remains are those of Eugenia, an eighteen-year-old resident in the early twentieth century who loved a man whom her family found unworthy. One night, an argument ensued, ending with Eugenia's brother stabbing the young man to death. Minutes later, Eugenia leaped to her death from the third floor. A female ghost has often been encountered on the third floor or has been seen through windows by people passing the building at night, pacing back and forth.

The Mansion's haunts were well known by 1985, when two New York paranormal investigators, Ed and Lorraine Warren, demonologists with forty years' experience in that field, visited Carrollton on a college lecture tour. They were taken to the Mansion to "substantiate the rumors of the former Mandeville residence being ghost infested," wrote Pritchett.

After their tour, the couple found the hauntings concentrated on the third-floor bedroom in the southeast corner of a turret. According to Lorraine, described as somewhat psychic, she felt a female presence while sitting on a sofa. "Everything seems to be centered around this room," Lorraine believed, and she discerned "the smell of flowers and smoke-from a pipe."

"She seems like a straight-laced type," Lorraine proclaimed. "A tall, gracious-looking woman, short hair, pulled back. She is tall, thin, with curly hair near her face…very dignified but very unhappy."

Additional spirits were identified, including a man described as "not a very nice person, very domineering. Very gray. He has facial hair, maybe a moustache…in his early sixties…wearing businessman-type clothing, gray… he is a very mean person."

There was also a child of six or seven who "was not afraid of the man."

The period was "very Victorian and by the dress of the period the time seems to be in the early twenties." The Warrens believed that the

Carrollton's Maple Street Mansion is haunted by three unrelated ghosts: a woman, a small child and an angry man. *Earline Miles*.

woman had died tragically and was "associated with the home, the room." The ghost man did not belong to the house, and the child was merely an impression. Lorraine felt the woman was "an earthbound spirit but would someday leave the house." She "was a very nice ghost." However, Mrs. Warren feared the man.

In 1985, a West Georgia psychologist invited Jay Anson to speak; Anson had written the popular book *The Amityville Horror*, which was made into a hit movie, and they obtained permission from Uglum to conduct a séance at the Mansion.

"It was pretty convincing," said Uglum. "They had described Eugenia perfectly. They also felt the presence of an older man and a little girl. They all seemed to Anson as being kind in nature, [except] the older man."

Uglum had purchased the Mansion a year earlier and started extensive remodeling. One August morning in 1988, before business, he and his wife were relaxing in the third-floor office drinking coffee. Suddenly, the sounds of a stereo and a television started blaring. The incident frightened him.

Most paranormal events occurred before or after business hours. Cash register drawers opened themselves, bathroom lights were extinguished

while people were using the facilities and multiple beer taps spontaneously and simultaneously opened.

"The last person to manage the place was so convinced the place was haunted that he would not put his foot on the stairs to even come up to the second or third floor," Uglum said. "He was convinced that she was up there and that she wouldn't bother him if he stayed downstairs. If there was a fire upstairs, he would have let the house burn down."

The Mansion ghost did not seem to have any evil intent, Uglum continued. "It has been mostly fun-type pranks, I'd say, versus actually scaring people to death or running them out of the house. I think there are good ghosts and bad ghosts, if there are any such things as ghosts. If she is in fact here, she enjoys being here and she's not trying to hurt anybody."

Maple Street Mansion, at 401 Maple Street, Carrollton, is currently closed and narrowly escaped demolition.

CATOOSA COUNTY

DO YOU WANT TO COME OUT AND PLAY?

The Southeastern Paranormal Research Society (SEPRS) operated out of Knoxville, Tennessee, and covered the eastern part of that state and occasionally northwest Georgia. It was contacted by the residents of a private home in Catoosa County who requested help with paranormal activity in the house.

Things were quiet for half a year after the family moved in, but they then experienced phantom footsteps, slamming doors and other anomalous sounds, consistently on a weekly basis. At the same time, white and black lights, described as round and snake-like, appeared.

After investigating the situation, SEPRS emphasized that the family were firm Christians. However, four years before the investigation, the female homeowner had obtained and used a Ouija board inside the residence. Her husband joined her on a single occasion. The board was later ceremonially burned in their driveway in 2006, which, according to tradition, is the only certain way to dispose of one. (When her Ouija board freaked her out as a teenager, my wife, Earline, attempted to throw it away. It kept returning.)

Both homeowners felt "a lot of problems with illness and energy," SEPRS reported. "They feel as if energy is sucked out of them and they are sick all the time."

The wife has seen a woman standing behind her and has been pushed in the kitchen and on the porch. She has also been scratched on her legs and found unexplainable bruises on her thighs. The woman has observed red lights in windows, stars in the bathroom, black objects that flew across

At Tunnel Hill, ghosts from a circus train wreck have been reported, and many Confederates linger from Civil War clashes. *Jim Miles.*

rooms and snakes crawling on legs. Lights have been turned off, items have disappeared and hot and cold spots have been experienced both indoors and out. Most ominously, she heard a voice calling her name. Despite all this, she did not believe that she was endangered by the phenomena.

The husband has seen the ghost of a man hanging from a tree beside the driveway and has seen shadows within the house.

The couple's two-year-old boy talked to an invisible playmate and has been heard saying, "Hey, boy" and "Do you want to come outside and play?" An eight-year-old son has not personally experienced any paranormal events within the house, but both boys were afraid to sleep in their rooms. The wife's father, who lives in the house, has seen a female apparition in his bedroom, and his TV turned on and off as he watched it.

Recorded EVPs included "Get out" and "Good dog," all in a female voice.

CHATTOOGA COUNTY

MURDER AT CORPSEWOOD

This eerie and tragic tale begins in Chicago with Charles Scudder, a pharmacology professor at Loyola University, a widower who had raised four sons with a "loyal friend and housekeeper" named Joseph Odom, a fifth-grade dropout. Scudder had taken him in seventeen years earlier, and the two men were believed to have a romantic relationship.

Scudder grew to hate much of his life—the crowded, noisy, crime-ridden city; the difficult medical students; and university politics. In the 1970s, he searched for property in the country where he and Joseph could live free from the stresses of modern life.

Scudder learned of a forty-acre tract of land on Taylor Ridge in Chattooga County, nearly surrounded by the Chattahoochee National Forest, which meant no neighbors for many miles. He visited the land and knew immediately that he had found his refuge from the world. He purchased the property on his return home. In 1976, on his fiftieth birthday, he retired from Loyola.

Scudder sold his house and most of his possessions, and he and Joseph headed for North Georgia in a Jeep, pulling an old camper in which they initially lived. Accompanying them were two one-hundred-pound English mastiffs, one named Beelzebub. Their tools included a chainsaw, a garden excavator and a small concrete mixer.

For two years, the men labored to clear the land and construct their "castle in the woods," a two-story brick house with a spiral staircase illuminated by a stained-glass window made by Scudder, without running water or electricity.

They dug and laid the brick foundation and constructed walls of three layers of brick, each layer separated by two inches of air space for insulation. They had a 160-foot-deep well drilled for water and enclosed a chemical toilet with a round brick outhouse. Their home, crowned by a pale pink stone gargoyle, was composed of forty-five thousand bricks they laid without previous experience.

After the first year, the ground floor was finished, with a living room, a dining room and a kitchen. By the second year, the upper story, with two bedrooms, had been completed. The house featured a kerosene-powered refrigerator, a wood-burning stove for heating and cooking and a generator for emergency power.

A garden allowed them to produce most of their own food—corn, cabbage, carrots, turnips and more—and they had a flock of chickens. The pair established a grove of fruit trees, set up a vineyard for making their own wine and installed beehives for sweetener. Without power, water, sewage or phone bills, they survived on $200 per month.

There was a circular rose garden and a brick gazebo with an upper deck where they had tea. A three-story chicken house was built, and they had plans to install a swimming pool.

The top of the chicken house, painted pink and named the Pink Room, was a party space where Scudder and Odom socialized and drank wine.

Finding a dead horse at the entrance to their property when they arrived, they dubbed the lane "Dead Horse Road," a "winding, logging-truck driveway." For the forest of barren hardwood trees surrounding them their first winter, they named their home Corpsewood Manor. Despite that grimness, it was their paradise.

Religion intrigued Scudder, a confirmed atheist, but he joined the Church of Satan out of curiosity. Some of his furnishings were occult-related.

Samuel T. West was a seventeen-year-old occasional truck driver who occupied a trailer in a nearby valley. In November 1982, Kenneth A. Brock, a thirty-year-old unemployed construction worker, moved in with West and heard about the "queer devil worshippers" atop Taylor Ridge.

Brock met the curious couple while hunting in the mountains and spent time drinking with Scudder and Odom. Brock, believing the pair must be rich, plotted with West to rob them, providing the young men the means of escaping their life of rural poverty.

On December 12, 1982, Brock picked up a .22-caliber rifle for "rabbit hunting." He and West started for Corpsewood that evening. On the way, they convinced Joey Wells and his date, Teresa Hudgins, to come along with

Folk artists, including Howard Finester, whose Paradise Gardens is preserved near Summerville, often feature religious and supernatural themes. *Earline Miles*.

the offer of free wine. They also huffed toot-a-lu, a concoction of glue, paint thinner and alcohol.

Scudder and Odom were surprised by the visit but welcoming, and Scudder and the four visitors climbed to the Pink Room. After they started drinking, Brock excused himself to fetch more toot-a-lu but returned with the rifle. Brock said, "Boom," grabbed Scudder by the hair and put a knife to his throat, demanding money. Wells and Hudgins fled but returned when their vehicle wouldn't start. They heard Brock's shouted demands. Brock bound and gagged Scudder with strips torn from a pink sheet.

Brock yelled for Odom to leave the house, where he was cleaning up after supper. When Odom emerged, he was shot four times. Brock then killed the two mastiffs. Brock forced Scudder into the house, where he saw his dead friend and canines and moaned.

Brock sat Scudder in a chair and removed the gag. Scudder stood and started shuffling toward Odom. He ignored Brock's demand to stop. Scudder said, "I asked for this." Then Brock shot him in the head six times. Brock, thinking Odom was still alive, shot him repeatedly. Scudder was fifty-six and Odom thirty-seven.

Brock and West found only some coins, jewelry, a gold-plated dagger and silver candelabras. Wells and Hudgins were told to stay quiet or they would also be killed.

Two days later, Raymond Williams, a friend of Scudder and Odom's, stopped by to relay a message and found them dead. Brock and West had fled but were soon arrested. They were also wanted for a murder committed while on the run in Mississippi. West told the Chattooga County Sheriff's Office, "All I can say is they were devils and I killed them, that's how I feel about it."

In court, the victims were put on trial as "homosexual devil worshippers" who drugged the defendants with LSD in their wine. Their defense failed. Brock received three consecutive life terms; West received a death sentence, later commuted to life. Joseph's ashes were strewn at Corpsewood, while a sister returned Charles's remains to Chicago.

Investigating police officers felt a strange presence at the scene while investigating the crime and thought they were being watched. After the murder, the "castle" was torched by arsonists. The curious who visit Corpsewood and take items, bricks and such suffer bad luck and believe that the objects are cursed. Visitors have seen ghosts and shadows, and at night, glowing eyes are seen in the woods, thought to be the ghostly mastiffs. Barking and growling dogs, gunshots and harp music have been heard. Scudder owned a harp, composing and playing tunes in his mountain redoubt.

When Ken Summers started work on *Queer Hauntings,* Corpsewood was the first chapter he wrote. The night he completed it, "I'm not ashamed to admit that I slept with the lights on," he wrote, and he "didn't sleep well that night." The story "chilled me to the core....I never felt alone while writing that chapter."

In an e-mail, a man named Danny described his exploration of Corpsewood with two friends. When they visited, the fire had occurred and the roof had crumpled. Once into the ruins, Danny "got a very strange feeling. Like it was the most peaceful place on earth. I felt like I belonged there." It was a good beginning to their expedition.

The three explored the ruins and were near a large rock, with steps cut into it, when a voice said, "Did y'all know these people?"

The frightened men whirled around to find "this guy, older and kinda ragged looking." Danny replied, "No," and the figure responded, "I did." He then "vanished in thin air." The trio "got the hell out of there and have never been back," Danny concluded.

One night on "Devil Worshiper Mountain," a young man saw "two glowing eyes looking at him, and it was Beelzebub, the mastiff." After a family visited the site, they burned their shoes in case "unholy mud, bad energy" corrupted them. One claimed it was "the creepiest place I have ever been. I was overcome with a serious sensation of dread, despair, and sadness" and felt physically nauseated. Thinking of the two terrible deaths, he declared, "They *are* at unrest."

An anonymous person wrote that he had visited the site soon after the house burned. Although he was only nine then, "I still remember the overwhelming presence of evil pressing on me." However, over the years, he has visited the site occasionally "and can say it doesn't feel like that anymore. Somebody must have prayed over it." He believes that "the devil has left Corpsewood Manor."

A man named Matt wrote that he heard "that there was a lot of satanic activity at the site...everything from people walking up on gutted dogs on the foundation surrounded by lit candles...to a hearse chasing my friend down the mountain." People have gone to the pond there for satanic rituals, he maintained. "I have heard they were trying to start a 'gateway' to hell in the ground...that they were trying to start the Church of Satan here on the east coast."

Mark E. Fults, in *Chattanooga Chills,* described a visit to Corpsewood by a friend, Robert Falls, and a female companion who excavated iris bulbs from the property. During the night, her house was plagued by poltergeist events.

When the sun rose, she dug up the bulbs and returned to Corpsewood, thrusting them out her car window and screaming, "I'm sorry! Here, have them back! And leave me alone!"

One visitor wrote that "every time I go up there something bad happens." Once "there were handprints all over the car. A local boy took a brick from there, then he got in an accident the next day and now he's paralyzed."

A woman named Susan had a horrific dream after visiting Corpsewood. First, a man appeared to show her a pile of bones. He was followed by a two-faced man, half normal, the other half "black and distorted…scary." She had a casual conversation with the normal side, but when the evil side emerged, "he was cussing and screaming like he wanted to kill me." Next, Susan entered the house to hide from a "huge beast," acting like it was "taken over by Satan" and "wanted to kill anything." Outside, the beast snatched up a woman "and pulled her chest to his mouth and bit her." Her chest exploded, with blood "gushing everywhere and spurting out all over!" Then she saw "this lady's soul being sucked up in its mouth!" The beast then said to her, "Play with me and I'll take your soul." She was badly frightened.

On the following day, a friend, Teena, called to report that she had a dream about Corpsewood in which her friend was killed by robed men who caused a building to collapse on her. Teena said, "I wouldn't worry about it 'cause you looked all different in the dream," saying her "hair was short and really blond." Susan was dumbfounded—just a day earlier, she "had my hair highlighted and layered short."

A woman named Janis revealed that she had visited Corpsewood but "didn't feel anything out of the ordinary. It is so beautiful and peaceful down there." Other visitors have found the site serene and never had a negative experience.

For additional details, consult Ken Summers's *Queer Hauntings: True Tales of Gay and Lesbian Ghosts*; *Chattanooga Chills* by Mark E. Fults; and "A Castle in the Country," an article written by Charles Scudder for *Mother Earth News* (March–April 1981; available online). Worthwhile but difficult to obtain is *Murder at Corpsewood: The Saga of Chattooga County's Devil Worshipper Slayings*, edited by James Budd.

CHEROKEE COUNTY

THE TOILET PAPER NAZI

Leisa J. Wilkie operates the Canton Ghost Tour and wrote *The Haunting History of Canton*. She grew up in the Buffington community on land owned by her family for five generations, where crops, livestock and children were raised. She lived in an old white house on a hill—surely an invitation for ghosts.

"From an early age," she wrote, "I can remember knowing that even though I was an only child, I was not alone." In that house, it wasn't "unusual to see or hear things at night." When her father was away working, she slept with her mother, which she thought comforted them both.

While swinging and watching traffic pass one day at age three or four, "I saw a nice-looking young man walking toward me," holding a long stringer of freshly caught fish. Although a stranger, he seemed familiar. Wilkie was alarmed by the man, but he smiled with kind eyes and spoke, quietly giving her a message for her mother. Wilkie scampered inside and related the message, which was from a "beloved uncle who was killed in World War II." It was her first ghostly experience, and it earned her a punishment for lying.

When Wilkie was about twelve, her mother bought a chord organ from a neighbor's yard sale. She took piano lessons but was only allowed to play her practice music, so she entertained herself on the organ. Once, as she played "Sweet Hour of Prayer," she felt a gentle, feminine touch on her shoulder, apparently from an appreciative listener. She turned to see the woman, only to find no one there. She raced from the room, "screaming for my mother." Her mother explained that it had been the "hand of God" but

later admitted that it had probably been her Aunt Mollie, a woman "who loved music but had very little musical ability."

Wilkie married, but after a divorce seventeen years later, she moved into the old family home. Several nights after returning, she "heard people talking, men mostly." She armed herself with flashlight and stun gun and searched the house. Finding no one, she searched again with the same results.

When Wilkie asked her father about the mysterious phenomena in the house, he said the previous owner warned him that it "was very much haunted."

As Ernie Hillard used her bathroom during a visit in 2008, Wilkie heard a man's voice mentioning toilet paper. When she asked Ernie what he had said, his reply was, "It wasn't me." He seemed "freaked out" for a while but soon calmed. According to reporter Marguerite Cline in the *Cherokee Tribune* on April 22, 2010, Ernie told her that as he washed his hands, he heard someone say, "You are using too much toilet paper." Wilkie decided that the ghost, dubbed Robert, was concerned that Ernie might use more tissue than the septic tank could manage.

One night, Wilkie had her television on and was watching a movie on her computer while she talked to Ernie on the phone. She heard Robert complain, "Too much damn noise in here." When she ignored him, Robert repeated the statement so loudly that Ernie thought someone else must be in the room with her. Nope, she replied—it was just Robert.

Wilkie and her father had heard chairs being moved at the kitchen table, utensils scraping plates and indistinguishable dinner conversation. One woman heard what sounded like a music box playing in the house. Toilets flushed themselves, men were heard walking around, invisible beings laughed and cabinet doors opened and closed. One particular door opened and sometimes remained open; at other times, it quietly closed or slammed shut.

As Wilkie wrote, "I did, after all, live in a haunted house."

CLARKE COUNTY

GHOSTS IN THE OUTHOUSE

Clarke County, with its many historic homes and a large university filled with anguished students, is one of the most haunted places in Georgia. Those ghosts have been described extensively, so I decided to include something distinctly different.

Here is proof positive that *anything* can be haunted. This story originated from the *Athens Ledger*, as reprinted in the *Savannah Morning News* on March 15, 1893. On Boulevard near Barber Street, there was an old privy where mysterious lights and strange noises were heard throughout the night.

"They say at any time after 11 o'clock at night lights can be seen moving about in this building and sounds resembling those of distress can be heard," the news account stated.

In Athens in 1893, one resident came upon an outhouse infested by a distressed spirit. *Earline Miles*.

One evening, a passing stroller heard what appeared to be a person in trouble and saw a light within. He threw open the door and went in boldly, but as he entered, the light and voice vanished. Disturbed by the phenomenon but intent on helping anyone in distress, he lit a torch and entered again to search for the victim. No one was present, and a thorough search of the surrounding area found no human presence.

CLAYTON COUNTY

ALL THE GHOSTLY NEWS THAT'S FIT TO PRINT

The *Clayton News Daily* occupies an antebellum structure in Jonesboro, where the Atlanta Campaign concluded and Sherman's March began. It is also a registered historic site where wounded Confederate soldiers were tended. Many men suffered there, and some died. The ghosts cannot be directly connected with the Civil War, but there is always a temptation to do so anyway.

Reports of paranormal activity are documented to the 1980s and probably occurred long before such records were kept. A medium was invited to tour the newspaper's offices twenty years ago. She reported that it was occupied by a male spirit named Patrick, with a last name something like O'Leary, O'Malley or McMalley. He was a Confederate soldier, and many refer to him as Jonathon Marcus McBain. Killed by a train while walking along the tracks, he was reportedly an aspiring journalist—that is why he inhabits the newspaper offices.

Many workers have seen, heard or smelled unusual phenomena in the building. Circulation employee Donna Goodson was alone in her office when she heard something in the mailroom next door playing with the conveyor belt. It sounded "just like if you were running your hand on the rollers." She checked and found nothing. "I do believe in Jonathan," Goodman said; she appeases the ghost with friendly conversation, bidding him good evening upon leaving.

"This building was here prior to the Civil War," Goodson related. "Soldiers were kept here and died as prisoners. Jonathan was one of those prisoners and actually died here."

The antebellum offices of the *Clayton Daily News* have a spirit that messes with equipment and sighs. *Earline Miles.*

Goodson has never been frightened by Jonathan's presence. She believes he is there to protect her when she works alone late at night and is comforted by the thought. Because Jonathan has established a routine, Goodson could predict when he would make an appearance, particularly when the building was altered. "Jonathan doesn't like change," she said. "We've done renovations through the years, and whenever something is done, he lets us know he's not happy with it."

Rita Camp, who manages circulation, refuses to believe despite experiencing the paranormal. Her office door opens for no reason, but "I'm pretty logical," she maintained.

Nick Lovelady usually reported for a sister paper, the *Henry Daily Herald*, but one Saturday, he labored alone in the Jonesboro office, with a TV turned on for company. "I just heard, you know, some crazy noises," specifically "heavy breathing, like 'hhhaaahh, hhhaaahh,' coming from the corner," presumably from an entity that had no reason to continue respiration. "I don't believe in ghosts," he stated, "but that guy—Jonathan?—he made me a believer."

COBB COUNTY

"MARY, MARY, WHY DID YOUR BABIES DIE?"

St. James Episcopal Cemetery near downtown Marietta at Winn and Polk is historic and beautifully maintained. Besides having its fair share of community founders, this cemetery is famous for two reasons. Many have visited the grave of slain child beauty queen JonBenét Ramsey. Far fewer are aware of Marion Meinert, often referred to as "Mary," and the tragic story associated with her grave monument.

The first mention of the story was in an *Atlanta Constitution* article written by Bill Wolfe on October 29, 1981. He reported that Marion died during childbirth, along with her twin babies. Grief-stricken, her husband commissioned a statue to place beside their graves. On the stone, Marion wears flowing robes and cradles a child in each arm.

Local legend claims that she cries at the thought of the tragedy, which some insensitive visitors attempted to exploit. If someone in the cemetery at midnight on Halloween circled the statue thirteen times and asked the female statue what happened to her babies, teardrops would form in the eyes and flow down the face.

The statue showed the effects of a century of weathering and, unfortunately, vandalism. Her nose and an arm of an infant had been chiseled off.

For the October 1, 1985 issue of the *Atlanta Constitution*, staff writer Dianne R. Stepp also investigated the legend. She concentrated on faculty members and students of Marietta High School, which stood directly across the street from the statue. That institution is now Marietta Middle School, and the statue has freaked out generations of young people.

A common rumor in Marietta claims that the ghost of Marion Mennert cries when teased about her tragic life. *Earline Miles*.

English teacher Dorothy Dyer related a story of the Meinert family: "They were supposed to have lived in a large house near here. The mother was downstairs and the babies were upstairs when she heard them cry. The house was on fire and she ran to save them, but all perished in the fire."

Former Marietta mayor Vicki Chastain, a Marietta High graduate, explained, "You're supposed to run around the grave three times calling, 'Mary, Mary, why did your babies die?'"

During two different ghost hunts in the cemetery in 2005, as related by Rhetta Akamatsu in *Haunted Marietta*, an EVP captured a little girl's voice saying, "Mommy." Two different investigators were standing near the statue when the batteries in their cameras suddenly died. Phantom footsteps were also heard on the grounds.

In this account, Mary is most likely to weep on the day of the deaths, October 13, particularly on rainy Fridays at midnight (although one wonders how the tears could be distinguished from raindrops) or on full moon nights.

In 2015, Ayanna G. visited the cemetery for an article on the now defunct Examiner.com. She noted that the statue was reported to cry blood or switch the babies from one arm to the other. Entering the cemetery, she said, "I immediately had the sensation that I had 'interrupted' something," like walking into a crowded room to see everyone cease their conversations to peer at the newcomer. The feeling was so strong that she "stopped walking and glanced round the entire cemetery" to ensure she was not distracting mourners.

Ayanna G. thought that "the statue's eyes were very intense, if not a bit unnerving." She "almost felt that I was intruding upon the woman's space. I silently asked for permission to take photographs," which she did quickly. However, overall she "felt quite comfortable" during her visit. Some sources have Mary audibly sobbing, while others claim that a ghostly woman makes a spirited appearance.

The facts are found on findagrave.com in the obituary of Marion R. Meinert from the *Marietta Journal* of May 26, 1898, with the heading, "The Death Angel Darkens a Home."

Mrs. Meinert was described as "a pure and good wife and a loving, devoted mother" with a charitable heart who served the poor and sick of her community. Born on October 25, 1863, she was only thirty-four when she died on May 21, 1898, at 11:30 a.m. of a lung ailment. She left behind a husband, Henry, and six children, including twin daughters four weeks old.

Meinert did not die in childbirth or in a tragic house fire, and there is no evidence that the twins accompanied her in death. Perhaps Henry Meinert simply wanted to memorialize Marion's last happy moments.

COWETA COUNTY

GHOSTLY ANGELS...OR ANGELIC GHOSTS?

Reverend Robert William Bigham was born in western Georgia in 1824 and devoted his life to serving the Methodist Church. He married Charlotte Elizabeth in 1858, but unfortunately, just fourteen years later, in 1872, she died while her husband pastored a church in Newnan.

One Sunday morning in early July of that year, Reverend Bigham devoted his message to angelic visitations. He read a number of biblical scriptures describing how angels delivered messages from God to men and women of the Bible and insisted that such incidents were not limited to biblical times and personalities, preaching that people to this day had seen angels and heard them talk and sing.

At this point, Bigham dropped his sermon bombshell. Since the death of his sainted wife

A Coweta County minister told his flock that he had been contacted by his angelic deceased wife. *Author's personal collection.*

earlier that year, God had allowed Charlotte to twice visit him, once by night and once by day. Soon after her demise, one night near the time of her death, Bigham had been "awakened by music, sweeter than earth can know, that he was fully alert, with every power of his mind in full operation, and

in fact, could see his wife and hear and understand her words as distinctly as the congregation could his." Mr. Bigham added, "I know I am neither insane nor superstitious, and yet, I would as soon doubt my own existence as the truth and reality of what I have told you."

The account of this singular message was reported in the *Newnan Herald* on July 12, 1872, by a reporter who insisted that there was not a more credible man than the minister and that he had complete confidence in the story. I have personally heard a number of similar tales from individuals I trust.

DADE COUNTY

AN ORDER OF GHOSTS TO STAY

On October 2, 2011, a six-member team from Ghosts of Georgia (GOG) descended on Trenton, located in the state's northwest corner. They were there to investigate "a home cooking restaurant with karaoke and store" that also had living quarters. The client had reported various paranormal activities, including shadow figures, disembodied voices, lights turning on and off, footsteps and doors opening and closing.

The team brought a digital camera, four video cameras, four EMF meters and two temperature gauges. The group was loaded for ghostly bear. While the team ate dinner there, Pat twice felt her head touched. "It felt like a spider web brushing the top of my head," she said, and no cause was visible. As Gretchen entered the kitchen for extra ice, she "heard a male voice in the back." Looking about, she saw no man in sight. She also heard a low voice and "pops and [a] crack."

Gretchen had "most of her experiences" in the bedroom, where she and Christine lay on the bed. Gretchen "heard a heh, heh, heh female breathy laugh," followed by the same laugh repeated, ending with "a loud pop!" "Heard voices and the laugh again, and the room became extremely cold," Gretchen reported. Then she felt "fingers" walking up a finger and then down an arm. When the sensation repeated, she told Christine, who asked the entity to touch her knee. In response, a "light lit up the room"; a flashlight in Gretchen's cloth tool belt had activated. Gretchen said the switch on the light had to be manipulated firmly for illumination.

When Gretchen asked that the flash be switched off, it merely dimmed ("my flashlight is either on or off…there is no half-strength"). The flashlight subsequently worked normally. The room then grew warmer. Apparently, the spirit had moved on.

Of the bedroom, the GOG report read, "Beth got heavy chest pains, tightness, and felt difficulty in breathing." Christine also felt the chest pains of a man and "had the name Addy or Manny pop" into her head. Beth picked up the name "Arthur Henry," which turned out to be the name of Gretchen's grandfather.

When Beth first entered the garage, she "had a vision of Jesus with arms stretched out in angelic fashion with clouds" hanging high on a wall. From the garage, swinging doors led to the main room. Beth heard the door hinges creaking, noting that the "doors appeared to have moved by themselves." Ed also heard the creaking hinges and was unable to determine why the doors moved on their own. Team members agreed that the doors seemed to open multiple times.

The entire team was present in the garage when a TV activated itself. The client had never seen it operate in the previous year. In an adjacent storeroom, Ed felt something grab his right wrist and "heard a disembodied

A Native American horseman is thought to guard the campground at Cloudland Canyon State Park. Hoof prints are sometimes seen in the morning. *Earline Miles*.

voice," which was also heard by Larry. Tapping at a door was heard. Pat and Ed saw that door move several times, and Pat observed a shadow pass by a crack between the door and frame.

The team "saw what looked like a black shadow move across the screen on the ceiling in the kitchen area," Pat reported, and "the kitchen lights turned on and then back off a couple of times." Others noted the same activity at different times.

Christine smelled a "strong burned smell," and in the kitchen, Gretchen noticed the "sweet smell of chewing tobacco" for two minutes. In the karaoke area, Beth felt "an area of strong energy." Ed felt a tickle on his wrist and a voice in his ear in the kitchen, where the team heard a rustling.

Larry saw a "distorted white mass" near the living room ceiling. EMF meters alerted several times, and a camera captured a looping orb. Heard from the main room was shuffling, ice being scooped and a chair being moved. In the kitchen, a recorder refused to work, but it functioned properly in another room. A recorder in the bathroom would not turn off but did in the kitchen. A recorder left near the TV was found to be erased and its battery dead. Something played with Christine's hair in the living room of the quarters, and she saw the dining room light turn on and off.

In summary, the team found this investigation to be "very interesting," as every investigator "had experiences backed up by other investigators," and they encountered "some of what the client experienced." GOG declared the property "active and haunted" and hoped to follow up to determine if a former owner, who died in the building, haunts it today.

DAWSON COUNTY

NATIVE AMERICAN SPIRITS INHABIT RESORTS

In *Georgia Ghosts*, Nancy Roberts related a story from Big Canoe, a resort near Jasper. Billy Howard, a fourteen-year employee, managed the Sconti Clubhouse for the community's many avid golfers. He had barely started his career there when, late one afternoon, he saw the figure of a man, described as tall and slim, in the men's locker room. It vanished but returned on numerous occasions, each time becoming more visible as it seemed to acclimate to being observed. Eventually, Howard could tell that it was an indigenous male, with long gray hair, clad in deerskin clothing.

The apparition appeared when the clubhouse was quiet and deserted and particularly liked Wednesday mornings, when Howard went in early. "He's always curious about what I'm doing and wants to watch everything," Howard said of the figure's behavior.

The ghost then started traveling through the structure, entering the pro shop, banquet room and kitchen. Eventually, the spirit added to its routine, which startled Howard when he saw it sitting at a table, clinking ceramic sugar holders together.

While the clubhouse was remodeled, the ghost apparently hitched a ride to Howard's home, where his young grandson asked if the man he saw was "going to live with us." When the renovation was completed, the spirit returned to the clubhouse.

Howard startled the ghost one day as he drove a golf cart unusually fast. To the man's amusement, the haint ran away. Of the spook's attraction to him, Howard thinks he understands. He is the seventh son of a seventh

The spirit of a Native American has been encountered in the lodge at Amicalola Falls State Park. *Earline Miles*.

son, and those so born are thought to have a second sight—the ability to experience supernaturally what others cannot. Big Canoe was definitely Cherokee territory, and Howard believes that this individual may have been buried on the grounds of the resort.

Housekeeper Gail Jones also experienced the entity, but not as vividly. Her encounters were with a "shadowy or misty" figure that appeared and departed instantly. She vocally greeted the ghost as she started working and once passed it as she left a room through double swinging doors. "One night, I was on one side…and it was on the other," she said. "We were nose to nose," for an instant, before quietly continuing on their ways. The ghost also brushed past as she was working. She emphasized that she was never harmed by the apparition, only startled.

Jones was frightened once when she approached her car one night and found a poorly defined figure in front of it. As she watched over a period of five minutes, it solidified into a man. "I was so scared I thought I would die," she stated.

Also in the mountains is a beautiful natural landmark known as Amicalola Falls, which features a drop of 729 feet and has been turned into a state park resort with a lodge.

Diana Reagan was a part Cherokee kitchen worker, according to Nancy Roberts, who felt something the moment she arrived at the lodge—"a sense of excitement and uneasiness," she said. Her feelings were reinforced one night as she worked at a hot dish washer and abruptly felt "an icy column of air beside me." Startled, Reagan quickly moved away with an exclamation that elicited knowing looks from coworkers. All had experienced the same phenomenon. Amicalola's spirit liked cordial cooperation among the staff and acted out when disputes arose. During one argument, a frying pan was sent flying toward two arguing employees and nearly struck them. Cookware had flown before in the kitchen.

Reagan and her Cherokee grandmother agreed that "the spirits of the ancient ones are up there," she stated. Her grandmother, referring to "our sacred mountains," contended that the ancient ones were communicating their displeasure with whites disturbing their former peaceful realm, just as they did at a ceremonial enclosure in Habersham County.

DeKalb County

THE COUNTY GHOST HOUSE

In the past, governments have preserved land and structures for their historic and architectural significance, natural beauty or rarity, but DeKalb County has gone a little further. Purposely or not, it has preserved a haunted home.

The Donaldson House, in north Atlanta, is a post–Civil War structure in the Piedmont Plain style of architecture. It had humble origins but underwent extensive renovations through the years.

James Donaldson immigrated to Georgia from Great Britain in the mid-1800s when he was twelve. He served in the Civil War for a time, settled in DeKalb County and started purchasing land for six dollars per acre. "He had a massive amount of land during that time," stated Danny Rose, president of the Dunwoody Preservation Trust. "One time, he boasted he could walk from Dunwoody to Chamblee on his own property."

Donaldson purchased one thousand acres to farm and constructed the house in about 1870. He fathered fourteen children between his three wives before his death in 1900. He is credited with attracting many settlers to the area. Behind the house is a cemetery, established after a devastating yellow fever epidemic in the late nineteenth century. Those interred include patriarch Donaldson.

In 1975, David and Linda Chestnut, he an attorney and once head of MARTA and she an interior decorator who taught college courses in historic restoration, were searching for a home with enough land for their daughter, Caroline, to have a pony. They discovered the Donaldson House

on a freezing day, but to them, the interior felt warm—they knew they were home.

The ghosts soon manifested themselves in various ways, but the family completely accepted them. "My daughter would wake up and there would be a lady there looking at her in the bed," Linda told *Atlanta Journal Constitution* reporter Dennis Lewis in February 2006.

"We have ghosts in our house," Caroline Chestnut Leslie said when she was forty-one. "They're just part of that house. They just don't seem to want to go on." She once informed high school friends that she felt comfortable residing with ghosts. "I got made fun of," she admitted.

"A lot of people don't believe that kind of thing," Linda said. "We do."

After the family moved in, they started extensive renovations. "When we pulled the sheetrock down off walls in the room upstairs, you could almost hear [the ghosts] dancing," David told Bo Emerson for an *Atlanta Journal Constitution* article published on October 20, 1983, "because it was back to the old wood walls."

Linda agreed, saying, "They seem to be glad we're here and have fixed the place up."

Linda often felt chills when spirits entered the room she was in, and she also observed smoky gray "forms." A psychic friend who visited saw an entire

A family of ghosts have been observed in Dunwoody's Donaldson House. *Earline Miles*.

family of ghosts, each wearing "frontier" attire, parade down the hall and exit through a closed door. A guest who spent the night watched a woman stroll into her room and admire the view out of a window before dissolving before his eyes.

The ghostly manifestations included a small child in dress and pinafore and an elderly man. Reverend Charlene Hicks, a Dunwoody psychic, was asked to tour the home and offer her impressions. "It had peaceful feelings," Hicks said. "They're friendly spirits there—no negative stuff. It's not like the spirits are trapped in that house and can't go to the light. They like being there."

In 1979, overnight guests were wakened at two o'clock in the morning by slamming doors, which were followed by music that sounded as beautiful as "the Mormon Tabernacle Choir." They assumed that David had just arrived and that the Chestnuts' daughter had turned on a radio. In the morning, they learned that the daughter had stayed overnight with a friend, and David was sound asleep at the time. No radio or stereo had been playing.

The ghosts enjoyed the Chestnuts' dinner parties as much as the living. While diners ate, the lights on the dining room chandelier would blink on and off. "Anytime we had guests who hadn't been here before, it happened," David said. "I got mad about it one time, and it hasn't happened since." Chestnut regretted his harsh words and its result. "What you've got to remember is that the spirits here are friendly."

Linda agreed, saying, "You've got good ghosts and bad ghosts, like you've got good people and bad people. Just because you die it's not going to make you good."

The paranormal "doesn't bother us," Linda stated. "We're quite comfortable with them. They're not belligerent, but friendly, fun-loving spirits." However, she added, "for their own sakes, [I wish] they would go on, but they're stuck here. There's nothing we can do."

The Donaldson spirits were once enamored of the family Bible, which rested on a table in the living room. Both David and Linda witnessed it levitate from the table, and he saw it drop on the floor, where it was always opened to the same verse. If they left the Bible opened to that verse, the book never floated. The levitating Bible "is the one thing that I've seen," David stated, that made him believe in the ghosts.

"A psychic came out and said a few words" over the Bible, Linda said, "and it stopped."

The family also believed that the spirits protected them during a 1998 tornado.

Fay Kemp, a landscaper who worked on the property for four decades, had once been spooked by an unusual noise. "I try to get out before sundown," she admitted.

The area became one of the most expensive in the region. In 2005, the County of DeKalb purchased the house and three acres from the Chestnut family, who had lived there three decades, for $1.2 million. The property is maintained and operated by the Dunwoody Preservation Trust.

The Donaldson-Bannister Farm (http://dunwoodypreservationtrust.org/properties-houses-cemeteries/donaldson-bannister-house-cemetery) is at 4831 Chamblee-Dunwoody Road, Atlanta, Georgia, 30338.

DOUGLAS COUNTY

THE GHOST PHOTOGRAPHS OF CHESTER HEATH

Chester H. Heath spent his working years at Lockheed in Marietta. His passion was hunting treasure and Civil War artifacts. While following (running) Indian trail signs in April 1971, he took a Polaroid picture of a trail tree (engraved with ancient symbols), and it developed with a "white disc" in the center. His wife informed him that he had photographed a spirit. After years of photographing such sites, he was suddenly able to capture the images of long-deceased Native Americans. In his book, *Spirit Photographs at Treasure Sites*, Heath related his stories.

While examining a location he thought was a chief's grave, "I had the peculiar feeling that someone was watching me very closely," he wrote. "It was a warm day and I was perspiring from the heat, but I felt a cold chill while in this area. I had had this feeling on other occasions, so I focused my camera and took the picture of the Indian grave." It revealed "what appears to be an Indian statue lying in front of a rock with the finger pointing to a five-pointed star on a rock above the statue," but no such statue or star existed. The heads of a bear and a cub were also seen.

On the afternoon of October 22, 1972, he captured five spirit photos. On one picture of a marked beech, the tree was clearly defined, but the carving was blurred. As he snapped the shot, "I heard what sounded like a woman's cry!" he wrote; he captured the face of a Native American maiden with a feather in her hair.

On September 2, 1974, he and a friend were panning for gold when "my friend became upset because he had a very uneasy feeling as if we were

Many Georgia ghosts have their origins from the death and destruction of the Civil War. This ruin is part of Sweetwater Creek State Park. *Jim Miles*.

being watched. Even though he and I both had our guns strapped on, this didn't ease his feelings so we moved out of this location." At that time, "his uneasy feeling went away, but as soon as we returned, he picked it up again," and they left for home.

"I have experienced this peculiar feeling many times in my treks through the wooded areas once inhabited by Indians long ago," Heath wrote. Photographs taken in such areas often revealed psychic signs. "In many of the pictures I have taken, there was nothing [spirits] on them; but some weeks or months later I would see different phenomena which apparently appeared after the pictures had been put up for a while."

Spirit Photographs at Treasure Sites is out of print, but copies appear for sale on Amazon, and you may obtain a copy through the interlibrary loan service offered at public libraries.

ELBERT COUNTY

GHOSTS IN THE TEXTILE MILL

One hot day in August 1900, the night watchman at an Elberton cotton mill failed to show up for work. The owner immediately hired sixteen-year-old Earle Broome. Ten owners and thirty-nine years later, Herbert Wilcox interviewed Broome for the September 11, 1938 edition of the *Atlanta Journal*.

In his four decades of work at the mill, Broome had become acquainted with three spirits haunting the complex, ghosts that had become a part of his accustomed nocturnal rounds. One ghost was that of a shy woman who only appeared in one place, Broome said:

> *She never comes around till after midnight and I see her first when I turn into the long alley where she used to work.*
>
> *There she will be in the dim light, working as fast as lightning, hurrying from one frame to another, and watching her job like a hawk, but never making a sound. I have tried to get close to her but every time I get near she vanishes through the wall like she was scared of something.*
>
> *I get a little blue, myself, when I see her because I have learned that when she comes, someone in the village is certain to lose a loved one. She must have come for her sister the last time she was here because the sister died next day.*

In life, a male ghost had boarded in Broome's childhood home and also worked at the mill:

The old gentleman was sick a long time and one Tuesday he disappeared. On Thursday they found his body in an old reservoir back of the mill where he had drowned himself.

Usually it is a rainy night when I see him and most of the time he is walking from the gate toward that old reservoir. But he is sort of restless and you can expect to see him wandering all around the place at times. I hadn't been on this job long when he played a prank on me.

I had just finished my rounds…when I felt something clammy tousle my hair and rub my face. I turned around right quick and there stood this old man with a teasing smile on the face just as he used to look at me when I was a kid. Before I could say anything he had faded away toward the reservoir.

I wasn't exactly scared, but I was sort of mesmerized so that I ran out and made my rounds all over again before I realized what I was doing.

Broome had never seen the third ghost, that of a black man who whistled an eerie spiritual tune behind the boilers on bleak winter nights:

Textile mills were dangerous places. One Elbert County mill counted three individual haints. *Earline Miles.*

I have never seen the Negro ghost, but I have heard him whistle a quiet little old tune so many times that I know it myself.

A colored man was killed here in the boiler room soon after the mill was built and it must be his ghost that whistles. Our head mechanic saw him once and he didn't believe in ghosts.

This mechanic had kidded me a lot about ghosts until one bitter night in winter he came to the boiler room to check up on some valves. He went behind the boilers and I heard him yell for me to come quick.

When I got to him he was as white as a ghost and stiff with fright. "I saw one of your ha'nts," he stuttered. "It was over by the boilers, grinning at me. From its waist down it was sort of a vapor, but from its waist up it was one of the queerest looking colored men I ever saw."

I had to go with that mechanic until we reached a street light. But he never laughed at me again.

Broome was not quick to accept anything unusual as a paranormal event. "Just because someone thinks he sees a ghost is no sign a ghost is there. And a lot of curious noises are nothing more than the building and machines groaning in their sleep as they cool off."

FANNIN COUNTY

A GHOST PLAYED "SOURWOOD MOUNTAIN"

Chickens a-crowin' on Sourwood Mountain,
Hey, ho, diddle-um day.
So many pretty girls I can't count 'em,
Hey ho, diddle-um day.

In 1971, Lawrence Stanley wrote *Ghost Stories from the Southern Mountains*, filled with tales of "ghosts, haints, and witches" seen or heard 'round "old houses, graveyards, churches, wells, mountain tops, roads, and trails for hundreds of years." He believed that there were explanations for many of these stories but admitted that people of the region believed in the supernatural origins of the tales. His fourteen stories described strange events in the mountains of Georgia and Tennessee, particularly in the vast wilderness of Fannin and Gilmer Counties. Here I relate his entry called "The Ghost that Played Sourwood Mountain."

Lawrence described the isolated nature of the region, where residents built their own houses and furniture and even hand-fashioned musical instruments, primarily fiddles and five-stringed banjos. The only music heard in the mountains was made by its inhabitants and usually consisted of songs they composed and arranged themselves. When the government decided to establish Chattahoochee National Forest, many homesteads were purchased and the former owners relocated. The old houses were demolished or left to deteriorate, their clearings quickly reclaimed by the forest.

Georgia's beautiful mountains are rife with tales of ghosts and other paranormal activity. *Earline Miles.*

Lawrence told the story of a successful May fishing expedition by two men, a trip that provided so many mountain trout that the men stayed until late in the day. Knowing that they could never reach home before nightfall, they looked for a good campsite. They shortly found an old abandoned homestead. The cabin still stood, and nearby, where a large cold spring issued from a hill, were the stone remains of a spring box, where residents had kept their milk and butter cool.

The fishermen placed their string of fish in the box, took split oak boards from the old barn and covered the spring box and then placed stones over the boards to protect against bears and other creatures that would like to dine on their catch.

The men cut spruce tips to form beds, got a fire blazing and cooked some of their catch for supper before darkness fell. One of the men decided to explore the old cabin, despite the danger of snakes. He returned and told his companion, "We might have done better to camp in the old house. There are benches around the fire place which still contains ashes and there is a homemade banjo without head or strings, hanging on a peg driven into the wall in one corner."

He asked his friend if he knew who had lived there. "Yes," replied the companion, "this is the house where they were having a party about thirty years ago. A young man was shot to death in the middle of the room while they were folk dancing. I guess that old banjo was the one somebody was playing when a jealous neighbor killed this fellow, because he was dancing with the girl he was courting. Did you see any blood spots on the floor? They used to be there."

It had been too dark to distinguish bloodstains, and they decided to look in the morning light. The men relaxed on their improvised beds and were soon fast asleep. Deep in the night, one was startled awake by the sharp sounds of a banjo and fiddle. Listening closely, he realized he knew the song, "Sourwood Mountain," an old and popular mountain dance tune. Frightened, he woke his companion, saying, "Wake up and listen, there is a dance going on right now in that old house."

His friend listened and agreed, saying, "I have been hearing it in my dreams." The nervous men sat up for the rest of the night. The tune eventually ceased, and no more music was heard. At first light, they grabbed their fish and left, stopping to prepare breakfast only when they were several miles distant.

As Lawrence concluded, the men "never forgot the tune Sourwood Mountain coming from an empty house, and a banjo without head or strings."

Ducks in the pond, geese in the ocean,
Devil's in the women if they take a notion.

The occasional copy of *Ghost Stories from the Southern Mountains* can be found online. Otherwise, request it through interlibrary loan.

Fayette County

IS A "DOC" HOLLIDAY IN THE HOUSE?

In 1855, John Stiles Holliday, a prominent physician, constructed the Holliday-Dorsey-Fife House next to the Fayette County Courthouse in Fayetteville. One of his nephews, John Henry Holliday, often visited his uncle here before moving out west and becoming famous as "Doc" Holliday at the OK Corral shootout in Tombstone, Arizona.

John Lynch, house manager of the historic structure, considered himself a skeptic on the subject of ghosts, but he had heard several unexplained noises in the structure. One "sounded like a large mirror" falling off a wall and shattering, he told Christina Barber for *Spirits of Georgia's Southern Crescent*. Yet a search of the house revealed nothing out of place. "There's no doubt there's strange acoustics in the house," Lynch said. "I'll hear someone coming up the backdoor landing. When I open the door, no one is there." The sound is loud enough to be heard throughout the house.

Besides noises and thuds, he noticed that objects placed on shelves were shifted or relocated. Lights were turned on and off at random. A particular problem occurred when he turned off all the lights as he left in the evening, only to find them burning brightly when he returned in the morning. Doors opened and closed at random, and the attic door closed by itself very slowly, but only when a person was watching.

One night in the 1990s, with the structure vacant and securely locked, a patrolling policeman reported seeing a person standing in an upstairs window. A search of the house produced no human intruder.

"Doc" Holliday may have lived at this house in Fayetteville, where a phantom walks about and locks people in the attic. *Earline Miles.*

It was believed that John Manny Dorsey was murdered in the house. A modern photograph of the house revealed a male figure staring out a window. The man resembled a photograph of Manny that was displayed in the building.

The attic was the scene of a scary event to a local storyteller, who practiced her craft there one Halloween. When finished, she was unable to open the door, which was not locked, only stuck. Lynch was forced to remove the door from its hinges before the frightened speaker could exit. "It never did that before," Lynch stated, finding the event "strange."

A number of paranormal investigators who have examined the house have had equipment malfunction. A force once ripped off an investigator's belt, and an EVP rasped, "Get out!" One group left a voice recorder operating and departed to tour a nearby cemetery. Upon returning, they found that the machine had recorded voices and steps as someone ascended or descended the staircase.

According to a video about the house, most of the ghostly activity occurs in the front northeast upstairs room, which hosts rotating displays.

The Holliday-Dorsey-Fife House was received by Fayette County in 1999 and opened to the public as a museum four years later. It is open Thursday

through Saturday from 10:00 a.m. to 5:00 p.m. Admission is charged. It is located at 140 West Lanier Avenue, Fayetteville, Georgia, 30214. Contact: (770) 716-5332; http://www.hdfhouse.com; manager@hdfhouse.com. Call or check the website for hours.

Christina A. Barber's *Spirits of Georgia's Southern Crescent* (Schiffer Publishing, 2008) is available online and at many Georgia bookstores.

FLOYD COUNTY

BLAME IT ON GEORGE

In 1970, Rome lawyer Roy Newman purchased a one-hundred-year-old house from a man who had occupied the residence for forty years. The owner did not mention any peculiar incidents, but Newman soon found out for himself. *Rome Times-Tribune* reporter John Ronner described the haunting in the October 30, 1975 edition of the newspaper. At that time, Newman lived with Linda Canada and their cat, Paca, which was terrorized by the phenomenon.

Canada was the only person to actually see the ghost. One day, she was watching television in the den when she felt an open palm pressed gently on her back. Startled, she whirled around but saw no one. Two weeks later, she and Newman were in the den one day, she watching TV and he reading. When she glanced up, she saw a tall, white-haired man standing in the hall. She quickly cried out to Newman, but the specter disappeared. Arbitrarily, they decided to name their ghost George.

On yet another occasion in the den, the TV seemed to develop a soft static interference. Manipulating the controls did not help, but then she realized that the noise originated from a radio in a corner of the room that had activated itself.

Paranormal experiences almost caused a housekeeper to quit. On one occasion, the vacuum cleaner started up without human assistance. On a different day, she was attempting to exit a bathroom, but there was strong resistance from the other side of the door. The woman was trapped in the bathroom for several minutes until the presence had its fill of fun.

George never did anything overtly frightening and could even be helpful. Canada entered the house carrying two bags of groceries and started to lose her load as she approached a closed hall door. George courteously opened the door, allowing her to deposit the bags in the kitchen. "Thank you, George," she addressed the air. It never hurts to be polite to considerate ghosts.

Of George, Canada said, "He has a kinky sense of humor. The bathroom and the hallway are his favorite places." George definitely liked the bathroom for some of his favorite tricks. While Newman shaved one morning, he felt the top of his pajamas being pulled. Looking at the garment, he could see it being actively tugged by an unseen force.

A friend who spent the night entered the bathroom in the dark and panicked when she felt something "soft and warm" on the wall. She shot out of the room in such a manner that it attracted the attention of others. A hastily assembled expedition soon entered the bathroom, activated the light and found only a solid, cold wall.

Newman's brother was disturbed while investigating a slave cabin in the backyard when unseen hands grabbed both of his wrists for a few seconds. Newman had heard that in the past slaves had killed the owners of the property.

This cemetery at Beech Creek Methodist Church in Floyd County is haunted by a nimble spirit child. *Earline Miles.*

An aunt and uncle were in the den once and heard pots and pans being vigorously banged about in the kitchen. They assumed Canada was busy in there until Newman arrived and told them that they had been alone in the house. The aunt never returned.

"It's definitely nobody's imagination," Newman said of the assorted supernatural pranks. "Too many people have heard them, together in a group. These are college professors, attorneys, secretaries. They aren't easily excited people." "I see the doors open and close with my own eyes," he said. "It's a weekly occurrence." Guests also heard doors open and close.

During a pool game with a fellow attorney, the guest dismissed the existence of ghosts. Instantly an overhead cabinet door swung open with considerable force, barely missing the scoffer's head. This raises interesting questions. Can a host be sued for injuries inflicted by their resident spirits and would homeowner's insurance cover damages?

Newman and Canada accepted George's presence as normal and came to pay little attention to his antics. Canada said that she would miss the friendly ghost if he departed.

Just before the news article appeared, Newman was reading in the den when he heard a door open and footsteps walking through the front of the house. No one answered his call, so he resumed reading. "It was just George," he said. No one was frightened, except for Paca the cat.

FORSYTH COUNTY

DEAD TALES TOLD IN SCHOOL

Cumming Public School, opened in 1923, housed all grades, first through eleventh, and offered the county's first high school diploma. The structure shortly burned but was reconstructed within the existing brick walls in 1927. Over the years, it served as primary, middle and high schools, finally operating as the Forsyth County Board of Education. The board transferred ownership of the building to the City of Cumming in 1999.

Local option sales taxes were used to restore the structure to its original appearance, and it was named to the National Register of Historic Places in 2000. A historical marker was added six years later.

The original tongue-and-groove pine floors and vaulted ceiling with beams were exposed in the school auditorium and modern sound and light systems added to create the 184-seat Cumming Playhouse. Stage plays and a variety of concerts are presented. Artifacts and displays of early Cumming history are housed in restored classrooms, and genealogical research is featured.

Part of the building was turned into Tam's Backstage, which offers food, drinks and catering and is available for special events. That is the part of the old school where most of the reported ghostly activity is experienced.

Near Halloween 2007, a team from Ghost Hounds investigated Tam's, an event covered by Jennifer Sami in the October 28 issue of the *Forsyth County News*. Accompanying the team was Reese Christian, a psychic and author of *Ghosts of Atlanta: Phantoms of the Phoenix City*.

Christian believes that a "trickster ghost," also known as a poltergeist, inhabits the eatery. This spirit moves objects around, and "people see him in

A 1923 school in Cumming is believed to be haunted by a former teacher who hanged himself there. *Earline Miles.*

the corner of their eye." As Christian walked toward a meeting room from the downstairs restaurant, she detected paranormal activity at the entrance to the playhouse. "I'm picking up...a hanging down there," she announced. "That's the first thing that's coming through very strong."

The suicide was apparently an educator, she continued. "I believe he was in a love affair with an underage girl, and I think something to do with this love affair sent him over the edge. He had a wife, I believe he had children, but he had a love affair with what would have been a 12- to 14-year-old girl. I think that's ultimately why he hung himself. I keep seeing a black cat. I'm seeing a black cat running around here in spirit."

In a themed room titled "A Midsummer Night's Dream," she sensed "a lot of poltergeist activity," created by a man who was "a sailor or in the navy, or something to do with ships and that's why we're feeling the whole swaying feeling...like he wants us to feel what he would feel on a regular basis. I feel a sense of falling a long way...he fell a really long way, and that's why I'm getting the sense of a free fall-a really long free fall. He probably fell to his death somehow."

As team member Shannon Mooney requested responses to questions, Christian reported that "a little girl and a little boy came up and sort of tickled your ear. Then both came up and on both sides of your head."

Before Christian spoke, Mooney felt the sensations, saying, "Did you see me touch my ear, right when that happened."

Overall, Christian stated, "I really get the feeling this place has been so many different things and with each layer, with each change, it leaves a whole other level [of paranormal activity]."

Christian believed that no negative spirits were present. "This place seems to have a lot of residual haunting," she stated. "I don't feel that there's anything really malicious or horrible. It's actually quite typical. Very rarely do you go someplace and encounter something very, very dark or scary."

Denise Roffe—another of the Ghost Hounds investigators, author of *Ghosts and Legends of Charleston* and co-founder of the Southeastern Institute of Paranormal Research (SIPR)—had previously heard stories of children's laughter being heard in the halls of the old school.

An anonymous report from someone who has worked in the facility said that people "will hear things coming out of [room] 202. Like walking on the floor boards." During a production of *A Christmas Carol*, the knob on the men's restroom frequently was seen turned by an unseen hand. A man who locked up alone one night left the stage and started up the aisle when he heard phantom footsteps "following behind him."

Finally, when managers of Tam's arrive in the morning, they discover "candles lit and music playing," although they knew all candles had been extinguished and electrical devices had been turned off when they left the previous evening.

The Cumming Playhouse, Tam's Backstage Restaurant, Historical Society of Forsyth County and Colonel Hiram Parks Bell Center for Southern History and Genealogical Research is at 101 School Street, Cumming, Georgia, 30040. Contact: (770) 781-9178; http://www.historicforsyth.com; http://www.tamsbackstage.com; http://www.playhousecumming.com.

Franklin County

THE SOUTHERN OAKS GHOSTS

The Lavonia mansion known as Southern Oaks was constructed in 1918 by Charles P. Ray. Many years later, Wayne Lawson purchased the property for renovation into a senior living facility. It later hosted weddings and other events.

"When we first bought the house, it was in bad shape," Lawson told Candace Smith of the *Franklin County Citizen* for its October 31, 2007 issue. "We had a lot of work to do on it. My father-in-law and I slept on the floor when we first bought the property because some of the window panes had fallen out. The first few nights were horrendous. We could hear people running up and down the stairs, and it sounded like people were having a party in the basement."

The father-in-law assured Wayne that he had experience with this type of situation and could deal with it. He opened the basement door and shouted into the darkness for the spirits to "keep it down" so they could rest and repair the home.

"We don't have the noises that we used to when we first moved in," Lawson continued. "My father-in-law attributes that to just talking to the spirits and explaining to them that we wanted to fix the house up."

When the facility was opened, "we had a large television in one of the rooms so everyone could come together. One night, a group of us were watching TV and we heard steps coming down the front stairs but we knew no one was upstairs."

As the footsteps reached their level and turned into their room, Lawson and all present saw a man wearing a suit of burnt orange walk across the room and through two tables and a door.

"Before everyone could start to panic, I had them write down exactly what they saw," Lawson stated. "We were all able to describe what he had on and how he had his hair combed. After that, anytime someone would knock on that door, they would hear the click of the lock and deadbolt unlocking, and the door would open by itself. We had to put a latch on the door and block it off to keep it from opening by itself."

Visitors to the house heard water facets turning when no one was in the bathroom, and toilets flushed as people sat down on them. Some were locked inside the downstairs bathroom, and a former owner could not open the front door when she wished to leave.

In January 2006, psychic Sharon Johns, who has worked with the Atlanta Police Department and has been featured on the Discovery Channel, walked alone through the house, exiting to relate details known to only one or two others. "She told us that we have four spirits, and unlike most places that have as many spirits, none of them have negative energy—they all have positive energy."

The spirits include a man who committed suicide upstairs, a woman who died downstairs in a bedroom, a man clothed in a military uniform who hid in the basement and a woman who resided in an antique grandfather clock the Lawsons had transported from their farmhouse.

That same night, a team from Paranormal Investigators of North Georgia (PING) conducted an investigation. Several orbs were encountered, and they "played with one of them. It even sat down on one of the guys' shoulder." Lawson does not revel in the ghostly activity, he explained. "I'm an ordained minister, and our religion teaches us not to believe in such things as ghosts and spirits [but] once you have these types of things documented and caught on film like we have, it's hard not to believe."

"We've completely set tables with wine glasses and teacups," Lawson told Jennifer Jones of the *Anderson Independent Mail* in October 2005, "and we've gone back to the kitchen to chill out and we'll go back out and one or two of the tables will be missing the wine glasses. But you look on the tablecloths and you can see the imprints where the glasses were sitting." The missing glasses were always found teleported to a shelf where they were stored. Curiously, the missing pieces were turned upright, while the others had been placed upside-down.

Southern Oaks was a senior living facility where many staff and residents watched a male ghost walk through tables and walls. *Earline Miles.*

In 2001, a bride wished to have her portrait taken at the front stairway. Fortunately, the photographer took several shots. "They ended up putting four pictures together because in one, her head would be cut off. Just blacked out. In another, she'd be blacked out from the waist down."

"There was a big party one night, and we had six people in the kitchen working, and a loaf of bread went flying over the girls' heads," Lawson said. "It just came off the shelf for no reason. There are occasions where we're having an indoor wedding and we're setting up chairs in front of the stairway. About half the time we've done that, we've gone into another room and come back to see that the chairs at the bottom of the stairway have been moved." The ghost "doesn't like to have those stairs blocked."

An apparition resembling lace floating in the air has been occasionally encountered; it disappears if touched. A mist with the image of a woman was seen floating at the upstairs hallway and around one particular room. Dissipating, it leaves behind a cold feeling to witnesses. While working upstairs on his computer, Lawson has seen shadows flitting about in the corner of his eye.

Lawson believes that what he encounters is the spirit of former owner Charles P. Ray, which is fine with him. "We all just borrow real estate while we're here anyway. If he built the house and wants to stay and not cause trouble, so be it."

Southern Oaks, at 30 Baker Street, Lavonia, was for sale at last report.

FULTON COUNTY

THE PINK LADY

In late 1947, the *Atlanta Journal Sunday Magazine* had a contest for the best "true ghost story" submitted by readers. More than two hundred entries were received, but the winner was from Mrs. Robert L. Gordon of Atlanta, who received a twenty-five-dollar prize. This story was published on December 28, 1947.

Mrs. Gordon wrote that when she was in her early teens, her family moved into a large house in Little Five Points. A long hall extended from the front porch to the back porch. On one side were three bedrooms; opposite those were the living room, dining room and kitchen. Each room was large, with high ceilings, "and I fell in love with the place from the first moment we saw it," she wrote.

One evening, soon after moving in, Gordon was sitting at the kitchen table chatting with her mother, who was cooking supper at the stove. "I had the feeling you get when someone is staring at you," Gordon stated. Turning aside, she was shocked to see "a woman dressed in strange-looking flowing garments of the palest pink." She seemed to be very young, with blond hair falling nearly to her shoulders, and one hand was outstretched. Her features were indistinct. "I just sat there staring and then she was gone."

Puzzled by her abrupt silence, her mother turned and said, "You look as if you'd seen a ghost."

"I think I have," the teen replied.

The family teased Gordon at supper about her ghost, and later in the evening, while mother described the incident to neighbors, "she felt a

There are no better conditions for generating ghost stories than constructing a school beside a cemetery. *Earline Miles.*

distinct tug at the hem of her dress." The incident "gave her quite a start," and she jumped, causing the neighbor's daughter to be "terrorized" and run into her house.

The Pink Lady made one more appearance. After Gordon and a friend had double-dated brothers, the two couples had returned to her empty house and were standing around the piano as she attempted to teach her date to play "Love in Bloom." As he played, Gordon felt the sensation of being watched. Thinking that her family had returned, she said, "How is he doing?" as she turned and found the ghost in the doorway between the living room and dining room, "half as distinct" as before. Frozen for a moment, she searched the house and found no one else present. When her family arrived half an hour later, they found "four rather apprehensive young people waiting."

On a number of occasions at night, Gordon and her mother would feel "the sensation of being accompanied by someone" as they walked down the hall, but the feeling disappeared at the kitchen door.

The family had a baby who had just learned to walk. One night, after putting the child to bed, the baby was heard crying. Gordon checked, but the child was fast asleep and the crying had ceased. Returning to her

homework, the baby was heard once again. Mother responded and found the child slumbering and the crying stopped. The cries were often heard by all members of the family, sometimes while the baby slept but also when the child was with them.

A final paranormal event was also associated with the baby. After several months' residence, the baby began waking up "screaming at the top of his voice." If the family responded quickly, they found him "sitting up staring wide-eyed at a certain corner of the room, screaming his lungs off." If the family did not react quickly, the child "would tear through two bedrooms, the hall, and the dining room and beat on the kitchen door. Invariably, he would go straight to the kitchen," which apparently represented his safety zone. After moving to a new residence, the child never once woke screaming.

The house was eventually sold, and the family relocated. Gordon and her mother loved the old house and hated to move, but other family members, especially her sisters, "were glad to go." The house was converted into an apartment with three or four units.

GILMER COUNTY

THE BLACK VEHICLE, A MOUNTAIN URBAN LEGEND

One night at the Mary Teems house, tales were told, according to *The Cold, Cold Hand: More Stories of Ghosts and Haunts from the Appalachian Foothills*, edited by James V. Burchill, Linda J. Crider and Peggy Kendrick.

"The worst place, I guess, for me," said daughter Sandy, "was Elf House. Every teenager for miles around has probably been there looking for ghosts, spirits, haunts, or adventure. There's something there. I don't know what, but I felt it."

The Elf House was a small, white painted residence constructed by a doctor who retired to the foothills of the Appalachian Mountains seeking solitude and inspiration to pursue a second career as a writer. According to legend, he had left in the middle of the night for unknown reasons, and no one else was willing to occupy the structure.

The house was a considerable distance off the main highway, approached by an old, deeply rutted red clay road. A driveway choked with weeds and saplings led to the tumbledown house, which was suffering the ravages of time and weather. Of course, the building, abandoned for many years, quickly gained a reputation for being haunted and attracted the adventurous and morbid attentions of many local teenagers.

Sandy and her friends parked near the house and hoofed it up the overgrown drive to approach the dilapidated clapboarded structure. As soon as they left their vehicle, they felt an eeriness that only intensified as they neared the building. They found it curious that a cleared, two-foot-wide path, devoid of weeds, brush and rocks that littered the surrounding

The mountainous terrain of North Georgia meant a sparse, rural population where ghosts and other folktales were commonly embraced. *Earline Miles.*

land, circled the house. At that point, the group was overcome by a shared sense of supernatural danger and returned to the car much faster than they had left it.

As they drove away, according to the account, "a black car with tinted windows appeared from nowhere and began to follow them." The mystery car emitted no engine noise and failed to raise dust on the dry clay road. When the teenagers reached the main highway, the pursuing car vanished just as it had appeared—unnaturally. "It's a place best left alone," Sandy said. "The cold there goes deeper than any chill I've ever felt, and I won't go back there. One warning to stay away is enough for me."

As teenagers, Sandy's husband, James, and his friends had also made a pilgrimage to the Elf House in the dark of night. The boys entered the building and examined every room, verbally challenging the haints to appear. Spying an axe hung over a door, they decided to take it as a trophy. In turn, each young man attempted to dislodge it, but none could budge the blade even a bit. Now frightened, the group ran to the car and jumped inside. Suddenly, a black truck materialized and chased the intruders down the eroded road, inducing the boys to race recklessly down the rough lane.

When the boys had first arrived at the house, they had noted an old clothesline in the yard, still standing but sagging and long unused. Upon leaving, they saw laundry, "newly washed, hung on the clothesline!" James related. "Only a few minutes before, they weren't there, and the hair on my neck stood up when I saw them. And the old black truck—I don't know where it came from, but it was there. And then, when we reached the main road, it was gone. I couldn't hear a sound coming from the truck, but it was bearing down fast on us as we ran like some kind of demon was chasing us."

GORDON COUNTY

TINKERBELL ON THE BATTLEFIELD

Resaca was the site of the first major battle of the Atlanta Campaign. For several days, May 13–15, 1864, the opposing armies hammered each other in the valley of Camp Creek. Neither side won a victory, but the Federals used their superior forces to outflank the Confederates, forcing them to retreat closer to Atlanta.

"Lynnlamb" submitted a report to the Shadowlands website describing a ghostly encounter he had experienced on the Resaca battlefield. It was May 1995, the closest weekend to the actual date of the battle, and he was part of a reenactment group. Reenactors love Resaca because they camp and perform on the 1864 battlefield, which is impossible on most Civil War sites today.

Lynnlamb's unit camped on a wooded hill above all the other two thousand reenactors. It was a beautiful, mild night so the men elected to forgo their tents and lay out in the open on their blankets. When Lynnlamb laid down to sleep, "it sounded like someone said my name in my ear," he wrote. He immediately turned over, but no one was there. The voice disturbed him, and he lay awake listening to the men talking and laughing below him. Eventually, the field fell silent, but soon "it sounded like someone [was] walking around our camp just out of the fire light." This happened several times, the sounds of someone approaching the camp, but always from a different direction. The footsteps stopped outside of the firelight and then receded. Fearing someone was trying to steal their reproduction rifles, which were stacked casually against a tree, he got up

Resaca was a major battle site during the Atlanta Campaign. Civil War reenactors have experienced paranormal phenomenon on the battlefield. *Earline Miles.*

and placed additional wood on the fire, just so the intruder would know that someone was awake. However, after he laid back down the sounds around the camp resumed.

By this time, Lynnlamb wanted reinforcements and a witness. He woke a friend, and while describing what had transpired, he spotted "a small light going up the hill at an angle away from us." Lynnlamb pointed out the light, and his companion shouted, "What do you want?"

The light "started down the hill toward us and I kept expecting someone to step into the fire light, but no one did." However, the light approached and stopped between the two men, who were separated by only three feet. For fifteen seconds it floated there and then ascended the hill along the same path, disappearing into the woods.

At this point, a third man awoke and demanded to know what was happening. After he was informed, the man said, "I'm telling you, I've been feeling it all night—there are ghosts out here." The other two men went back to sleep, but Lynnlamb lay awake for some hours, "a little bit more than scared."

In the morning, the first friend tried to explain the incident as a firefly. "How many lightning bugs have you had come to you when you called out to them?" Lynnlamb demanded. It was something to think about.

The State of Georgia has purchased a substantial portion of the Resaca battlefield (http://www.exploregeorgia.org/listing/56643-resaca-battlefield-historic-site) and is developing a historic park. Reenactments are held faithfully each spring.

GWINNETT COUNTY

THE LOCOMOTIVE AND THE GIANT GHOST

The Lawrenceville Branch Railroad, completed in 1881, was a ten-mile-long narrow-gauge track through Gwinnett County, connecting Lawrenceville and Suwanee. In mid-February 1889, according to the *Atlanta Constitution*, a conductor, Collins, had left Lawrenceville before dawn and was startled to see a man one hundred yards ahead standing directly in the center of the tracks. The figure was waving his arms and crossed and recrossed the rails. As the locomotive got closer, Collins "found that the volume of the person or thing increased enormously. Whatever it was, it became larger as he approached it. It seemed to stretch out arms three or four feet in length. Mr. C.A. Bern, fireman, also noticed it, and he says it became as large as a good-sized horse before it left the track."

The figure, now thought of as a large ghost, "turned around and took down the track running like 'wild fire'—was fast distancing the engine, when it left the track and sped its way into the woods and stopped for the train to pass." Collins's son, Willie, along for the ride, asked his father what it was. Neither Collins nor Bern had any idea.

The odd ghost made a second appearance on the following day. J.S. Glover was employed by the Coffee Livery Stable and started work before dawn. Approaching the stable, he sighted what he thought was a bay mule belonging to his employer that had escaped its pen. When the animal jumped a six-foot-high garden fence, Glover ran to catch it, but the creature jumped back over the fence and sprinted away. From up close, Glover realized that he had not encountered a mule. "He declares it was large as an elephant and jumped like a cat," the press account stated.

HABERSHAM COUNTY

ANCIENT GHOSTS

Our Habersham County ghost tale allows me to give both an anthropological and archaeological lecture in addition to the usual paranormal story.

One of my favorite ancient mysteries are the crumbling stone enclosures found scattered across the state, from middle Georgia through the mountains, but primarily in the north. The best-known example is Fort Mountain, located atop the rugged Cohutta Mountains of Murray County. This enigma is also the only preserved example of a stone "fort" in Georgia and the sole one that can be reached with any degree of ease and safety as part of a state park.

The "fort" from which this elevation takes its name is an 885-foot-long wall that meanders across the rugged, 2,800-foot-high summit. The wall is 12 feet thick at the base, but only 2 to 3 feet in height. Some experts believe that the wall was once 7 feet high or perhaps surmounted by a wooden palisade. At each end of the wall is a large square pit, and twenty-nine inexplicable pits, often called "foxholes," appear at irregular (but usually 30-foot) intervals. The pits average 3 feet in depth.

The thousands of rocks that compose the wall range in size from small stones to rocks that would require several strong men to transport. Enormous natural boulders peaking above the surface of the slopes were incorporated into the work. The wall is composed completely of loosely piled granite rocks gathered from the mountainside. The enclosure commands the practical route to the northern summit, which is 250 feet higher than the remainder of

Supernatural entities once kept an ancient enclosure in Habersham County clear of debris deposited by inconsiderate settlers. *Earline Miles.*

the peak and encloses eight acres of reasonably level land. The wall zigzags irregularly across the mountain's northern face, the angles and length of each varying considerably.

The estimated age of these enclosures is considered to be about 1,500 years. Their purpose is thought to be ceremonial, which means we have no idea for what purpose they were constructed, but these artifacts probably were not defensive works.

Habersham County has two of these curious artifacts. On Alex Mountain is a stone "fort" that has the same type of "foxholes" as at Fort Mountain. A broad oval in shape, it has a diameter of 107 feet and stretches for 92 feet from east to west. My wife, Earline, and I have climbed the steep slope to visit it, where the work exists in an undeveloped state. We have also seen the other circular stone wall in Habersham that has a wonderful Cherokee legend attached to it.

Part of Cherokee folklore involves the Nunnehi, translated as "dwellers anywhere" and meaning "those who live forever." These usually invisible, supernatural beings were generally benevolent, often mischievous and, when disturbed, malicious. Their nature seems to be part European fairy and part ghost. We will err on the side of ghost.

Along an old trading path that led from South Carolina to the old Cherokee Nation, near the head of the Tugalo River, there is a "noted circular depression," reported James Mooney in *Myths of the Cherokee* (1900), a book that is regularly reprinted and belongs in the library of every Georgian. The enclosure is roughly one hundred feet in diameter, which Mooney thought was roughly the size of a Cherokee council house, and waist high. "Inside it was always clean as though swept by unknown hands," Mooney wrote. "Passing traders would throw logs and rocks into it, but would always on their return find them thrown far out from the hole. The Indians said it was a Nunnehi townhouse, and never to go near the place or even to talk about it."

Eventually, the Nunnehi tired of cleaning up after the white intruders. When traders threw logs into the enclosure on one occasion, the trash was allowed to remain. The Cherokee believed that "the Nunnehi, annoyed by the presence of the white men...abandoned their townhouse forever."

This archaeological treasure is located near the community of Batesville, not far from the scenic Soque River. Forty years ago, while chasing this *Myths of the Cherokee* tale, Earline and I pestered the good people of Habersham County until we were directed to an elderly, retired elementary school teacher, on whose property the artifact lay. She was happy to talk about it and led us up a ridge to where it occupied a clearing. We were both in our twenties and she in her seventies, but we were ashamed at how she blazed a trail up the ridge that left us panting in her wake.

The enclosure was barely two feet high, but the outline of the wall was clearly distinguishable. Unfortunately, it was packed with fallen tree limbs, leaves and other debris. "I wouldn't mind if the Nunnehi returned and cleaned this thing out again," the landowner said quietly, before leading us down the slope to some wonderful homemade lemonade and cookies.

Read *Myths of the Cherokee* and you will understand that the Native Americans of Georgia had regular interactions with supernatural forces. Copies are often available in local libraries and always for sale online. For a lengthy account of Georgia's numerous ancient stone mounds, read my *Weird Georgia* (2000, Cumberland House). See http://gastateparks.org/FortMountain.

HALL COUNTY

THE LIBRARY GHOST THAT ANSWERS THE PHONE

More than a century ago, the land was occupied by the home and cemetery of the Brown family. In 1926, the graves were removed to Alta Vista Cemetery and the house transported to Broad Street in Gainesville. The property became the location of the Wheeler Hotel, where a woman was murdered. After the site hosted a drive-in bank, Hall County constructed the Gainesville branch and headquarters of the Hall County Library System there.

The legend started with an undated "Our Heritage" column in the *Gainesville Times* that mentioned that after closing one night, a mysterious woman dressed in black was seen in the rear of the building, near the elevators. Then, while the library was closed on a holiday, a caller enquired if the facility was open and was somewhat surprised when the phone was answered by a woman, who assured the caller that the library was open until 9:00 p.m.

On many occasions since, a strange woman dressed in black has been sighted by employees near closing time. Some have reminded the lady of the closing, but no one has ever seen her exit the building despite thorough searches that proved she was no longer present. Every witness has described the same person, said Sybil McRay, a Hall County genealogist.

"I feel like we've traced her back to [the Victorian era] based on different people's descriptions of what she's wearing," Gail Hogan, library assistant, told the *Gainesville Times*. "Based on the descriptions she was wearing a long dark skirt, a light colored top with a light shawl and a broach [*sic*] at

her neck. [One witness] said she had dark hair that was pulled back from her face and that she had a rather plain-looking face, and even though she was probably young, she looked much older."

The specter has been dubbed Elizabeth, a popular name for women from those times. Another nickname is the "Lady of the Library." On a frequent basis, books left properly shelved the night before litter the floor in the morning. A copier in an unoccupied room turned itself on, and book scanners have also been activated by Miss Elizabeth.

In 2007, Hogan, an employee since 1990, said that each morning when she arrives at work she greets Elizabeth. The spirit has turned the water back on after employees have washed their hands in the restroom, and she is fond of fooling around with the lights. "I think she has a sense of humor," Hogan said.

A female figure has been sighted repeatedly at the Hall County Library in Gainesville. Sometimes she peers out a window. *Earline Miles.*

Hogan believes that the spirit is related to the Civil War. Tradition has eighty-one men marching off to war from this property in the summer of 1861. "The group was Company A of the 11th Regiment of the Gainesville Light Infantry of the Confederate army," Hogan stated, and it is believed that "thirty-one of those men did not return."

The men marched off to the north, and a library patron standing where the ghost is usually seen can see in that direction. "That far window that faces toward Brenau [University]," Logan said. "They would have marched in the general direction, and that area is predominantly where Miss Elizabeth has been felt." Coincidentally, that is the place where a collection of Civil War books is shelved.

Hogan and Kathy Amos, a local storyteller and a board member of the Northeast Georgia History Center, asked the Paranormal Science Investigation Network (PSIN), from Lawrenceville, to examine the haunting in September 2007. During the investigation, one of the spook cops, Michelle Babiarz, witnessed lights being switched on and off, and books tumbled from shelves as she worked. A preliminary walkthrough had found no books on

the floor, but as the investigators roamed around the library, they found two books on the floor in the children's section. One, titled *The Serpent Slayer*, about strong women, was found three feet from its shelf.

The ghost hunters split into two groups; one went upstairs and the other remained downstairs. Their equipment included digital recorders, digital cameras, motion detectors and meters that detect changes in electromagnetic fields. Several minutes after Hogan asked Miss Elizabeth to turn on a light, a hall light turned itself off and immediately back on.

HARALSON COUNTY

PRE-OCCUPANCY INVESTIGATION

Haeli and his family moved into a 110-year-old house in Tallapoosa one November, but he had been hunting ghosts in his future home since Halloween. On October 31, Haeli, a brother and a friend snuck into the structure, which they suspected was haunted; there was even a gravestone beside the house.

The trio entered the dwelling in daylight, but nothing happened until they entered the basement, where they heard "a really loud bang in the crawl space," Haeli wrote in *Ghosts of America*. That was followed several minutes later by "a footstep above us in the kitchen." Throughout their visit, the boys were alone in the house.

The valiant ghost trackers went upstairs and asked the ghost to identify itself, and "me and my friend heard a woman's voice," faintly. They could not understand what was said, but both had distinctly heard it. The voice was not audible on their camera, but "just before that happens an orb appears behind my friend and floats upwards."

The boys left the house, but they returned after dark with another of Haeli's brothers. In the kitchen, they heard "a loud, quick tapping noise," and all backed away from its apparent source. Later, Haeli and his friend approached an upstairs bedroom that he would occupy, using their phones to record possible EVPs. When Haeli first entered the room, he greeted the ghost with a cheery "Hi." When their recordings were played back, "you can hear a man's voice saying a drawn out 'Hiiii.'" Haeli next asked if this was the spirit that had made the tapping sound downstairs. The recorded reply was a quick, "No."

Two children lost their lives in this Haralson County creek, and their dead mother continues searching for them. *Earline Miles*.

Since moving in, "I've heard footsteps in my room at night" and a phantom thud in the kitchen. "One time I looked up at the attic window and thought I saw someone draw back from the window." One brother, who lives in the basement, has heard a voice and the sound of something falling down. Neighbors informed the new residents that the house was haunted.

Haeli said that overall "nothing really happens all that much. Whatever is here isn't harmful at all; it's a peaceful being. I just wish I knew who it was. I know there's something here. I can feel it."

HART COUNTY

ANTICS OF A FEMALE SPIRIT

In 1978, George Pittman and his wife, Joan, both teachers with advanced degrees, along with their daughter, Lisa, moved to a rural Hart County home that had been constructed seventy-five years earlier. It had stood unoccupied for about twenty-five years. Each member of the Pittman family separately had paranormal experiences on the property but kept it to themselves for several years. George Pittman wrote their story in the May 20, 1984 edition of the *Atlanta Journal Constitution*.

Each evening, around 10:30 p.m., Joan accompanied the dog outside and let it loose for a few minutes on their fifty-acre property. One night, the dog jumped down the back stairs but soon started growling and backed up the stairs. Fifty feet away was a soft light that shifted back and forth. Chilled, Joan immediately reentered the house. Lisa, whose room was near the spot where the light was seen, had observed a mysterious light and heard something moving about outside her window and knocking on the wall.

The most frightening event happened to George. One fall afternoon, while collecting pecans near the eerie spot, he "happened to look up and saw the apparition of a young lady, dressed in a pre–Civil War peach-colored gown," he explained. "She was blonde, with her hair in ringlets and appeared to have on rouge. The vision lasted perhaps 3 to 5 seconds. She moved her hand to her cheek, turned away from me slightly, and just disappeared." George managed to dismiss the ghost as a trick of light.

One night, while Joan and one of her friends spun wool, the friend's husband and four-year-old son waited outside in their car. "Look at that

woman over there," the boy said to his father, pointing. The father saw no one, but the son insisted she was there and could not understand why his father could not see her. We know that children (and pets) can discern ghosts that are invisible to adults.

The Pittmans did not disclose their supernatural events to one another until after the friend related this story. The friend also said she was somewhat psychic and felt "uncomfortable and unwelcome" in the house, with those emotions emanating from a "presence."

All three of the Pittmans separately had observed objects that would disappear for a short time "only to turn up in unlikely places," particularly books, which were found across the room from the bookshelves and would shift in numbers from one to five. Jewelry, hairbrushes and other personal items of Joan and Lisa's were likewise teleported.

All three confessed their experiences on a Christmas trip, and back home, the ghost kept up its antics. Room lights hung on cords from the ceilings, and one hot, still summer night, the "light in our bedroom began swinging in a 3-foot arc," George noted. "Nothing else in the room moved. No earthquake. It swung for several minutes and then stopped. It did not slow down. It just stopped."

Loud knocks were often heard on the couple's bedroom door, on the ceiling and on the side of the house. Investigation revealed no possible human source for the sounds. Once, a stout candleholder, three inches in diameter, was found smashed to pieces.

A year later, George and Joan had just gone to bed when, abruptly, the myriad country night sounds ceased entirely. "Joan and I had a feeling of some presence outside" that had caused insects and birds to cease their normal cries, George said.

One night, around ten o'clock, a "tremendous crash" occurred in their bedroom. Initially, they thought a bookshelf had collapsed, but they found that "a metal trashcan had been kicked across the floor. It was caved in on one side."

The most unique incident occurred just before George submitted his account to the newspaper. While standing in the bathroom, "something cold moved against me from my waist to my shoulder and about one-third of the way into my body," he stated, filling him with an "intense chill."

George shifted several feet, yet "it stayed with me, as if something had moved part way into my torso." Visually, he saw nothing unusual. "The feeling began instantly and ended instantly." He was not frightened by the event, just curious about the effect.

George talked to their neighbors and investigated the history of the house, but his research revealed no anomalies. He suggested that perhaps the psychic occurrences were triggered from Lisa, a high school senior who was upset about the move to a rural locale. As she adjusted, the phenomenon lessened but did not cease.

HENRY COUNTY

OUR UPSTAIRS NEIGHBORS

The McCurry Homestead was constructed in 1837 in Stockbridge. In late March 1983, Donna and Doug Chester, with their twenty-month-old son, Scotty, signed a long-term lease on the property and moved in, beginning an extensive renovation of the 172-year-old house. Because of termite damage, they ripped down sheetrock in the living room to replace the original wallboard. That intense activity apparently woke something that had long slumbered.

On April 7, a week after moving in, Doug was at a work meeting in town, leaving Donna, Scotty and Gypsy, their dog, at home. Donna put Scotty down for the night and spent several hours by herself in the dining room. When she heard a baby cry two hours later, she went to check on the child, who was sleeping soundly. Back in the living room, she heard the baby continue to cry, and Gypsy was peering intently into the dining room, ears perked. When sounds like someone walking back and forth upstairs were heard, Donna turned up the TV and attempted to ignore it. Later, she attributed the incident to her imagination.

With Doug gone again on the night of April 12, Scotty was placed in bed, and the crying and pacing started again, "as if someone was walking a baby," Donna described in an account published in the *Atlanta Journal Constitution* on May 20, 1984. Donna walked into the dining room to peer up a steep flight of stairs.

"As I turned on the light and looked toward the stairs, I saw a beautiful young woman in her mid-20s coming down the stairs. I could see the wall

through her body. She had blue eyes and dark hair, which was bunned in the back and rolled around her face. She was dressed in a long white dress with a high neckline, empire waist, and puffed sleeves."

Donna continued: "The woman was holding a tiny baby in her arms and moved a hand across her face as if to wipe off tears. She looked at me and shook her head and said, 'The baby just keeps crying.' I knew then it was not my imagination." The lady turned, ascended the stairs and entered a storeroom that Donna later learned had been a nursery.

When the Chesters moved in, Donna's mother was left alone at the house for a time, and she heard not only footsteps on the stairs but also voices. Not long afterward, Donna removed a vase of flowers from the dining room table and placed them on the stairs. The following day, the vase had been returned to the table. Donna replaced the vase as an experiment, and the flowers were again returned to the dining room.

Doug and Scotty also had paranormal experiences in the house. Doug heard the crying baby, pacing and even what he identified as a baby carriage being rolled across the attic floor.

As Scotty got older, he once ran into the living room to describe a smiling lady on the stairs. He was also seen sitting on the living room couch talking to the smiling woman and was often found on the steep stairs, where he was not allowed, because he wanted to "play with the little boy, Mom," he explained.

The entity, dubbed "our upstairs neighbor," was active during renovations in the spring and summer but disappeared for the autumn and winter until February 1984, when lightning during a terrible thunderstorm struck an old oak tree in the yard with the sound of "100 sticks of TNT going off," Donna wrote. The home, only thirty feet away, shook as if about to collapse. The electricity failed, and Doug went for a flashlight in the kitchen. He found the temperature twenty degrees colder in the dining room than anywhere else, despite a wood fire blazing in that room, and "standing on the stairs in a soft light was our lady. She stood there looking at Doug for a minute or two and then turned and went back upstairs."

The neighbor upstairs quieted considerably, but any unusual commotion, a party, shifting of furniture or a sick Scotty elicited her presence in the living room and attic. Research into the history of the house and its inhabitants revealed no mysteries, and a man who moved in back in 1935 never experienced anything out of the ordinary. Perhaps the relationship of Donna and Scotty prompted the ghostly lady and child to appear.

JACKSON COUNTY

LITTLE JOHN HAUNTS CITY HALL

Braselton got its start in 1876 when William Harrison Braselton moved his family from Hall County and purchased eight hundred acres of land for a plantation. The town was incorporated in 1916, when William Henry Braselton was elected the first mayor. Braseltons dominated the mayoral position for most of a century, as well as the city council.

Braselton soon became a commercial center for the region when eight-year-old John Oliver constructed a small store that served plantation hands. Two brothers joined the enterprise, and a store on the railroad was eventually built. In 1904, Braselton Brothers, with the motto "Deals in Everything," had a large brick warehouse, selling groceries, dry goods, shoes, clothing, millinery and notions.

Braselton had a brief brush with fame in the late 1980s when Georgia actress Kim Basinger headed an investment group that purchased 1,800 acres of the community for $20 million. The idea was for movie and audio studios, a film festival and boutiques. The plan failed to materialize, and the land was sold in 1993 for a mere $1 million.

Braselton's town hall was constructed as a home in 1909 by Henry and Pallie Harrison. The two-story Greek Revival mansion featured four large front columns and a row of smaller columns surrounding an extensive porch. The Braselton house had been unoccupied for forty years when the city purchased it in 1995 for civic purposes. A museum-class, $500,000 restoration followed over the next few years, work that generated considerable enthusiasm among the citizens. The building is decorated with antique dressers and cabinets.

The ghost of Little John, a former resident of Braselton's municipal offices, pounds on walls, vandalizes offices and frightens police dogs. *Earline Miles.*

The restored town hall has conference, reception and meeting offices, with spaces for the mayor and council. The town council meets around a table in the old dining room, while the public occupy couches in the former living room. "We think we have the prettiest town hall in Georgia," said Henry E. Braselton, the last family mayor, in an *Athens Online* article written by Erik Tryggestad and published on January 24, 1999. Braselton noted that there had been weddings in the house and also "one or two deaths."

Town hall employees, past and present, have reported unusual phenomena within this public building. One day, two workers who stood conversing at a window near the attic heard a strange knocking from within a closet. By day, that sound has emanated from other closets, windows and the attic. Footsteps on the staircase were heard after the building had closed for the evening.

Employees have returned to work in the morning to find desk drawers and cabinets, left closed and locked the previous evening, wide open and unsecured. Mornings have also revealed various objects moved about the building while no one was present.

A police dog has refused to enter the city council conference room, whining and backing away from a presence it perceived.

During a wedding reception held in town hall, one guest, a self-described psychic, related that he had seen people dressed formally in the style of the 1920s standing about in the hall. He and others have seen one particular lady, probably one of the early Braseltons, in and around the downstairs bathroom.

Some say that the primary spirit here is "Little John," presumably John Oliver, the young entrepreneur, who was said to have had a mental problem. He collected stray dogs and lived with them in the attic of the building until his death at a young age from unknown causes. It is said Little John is simply trying to attract attention. Some employees laugh at these stories, but others grow anxious if working late in the evening or alone in the building.

Braselton Town Hall is at 4982 Highway 53.

Lincoln County

THE GHOST ON THE STAIRS

In the November 19, 1933 issue of the *Atlanta Journal*, as part of a "Ghosts I Have Met" column, consisting of true paranormal stories submitted by readers, Alice Guillebeau Albea described "an old three story house about which many strange things are told" in Lincolnton.

On an evening years before, around nightfall, a boy was descending the stairs from the second floor when he glanced up and saw a man coming down the stairs from the third level. "The man was fully dressed, wearing a stiff-bosom shirt, high collar cut away coat, and carrying a walking cane," Albea wrote.

The young man sprinted down the stairs and tore out the front door to where his parents sat on the porch, "with eyes big as moons and panting for breath." He told his mother and father what he had seen, but a quick and thorough search proved fruitless.

Later, a neighbor said, "this was the exact description of the manner in which a former resident had dressed." The man in question had died in the house several years earlier.

The house also had the odd reputation of being a "weather prophet," according to residents. Before a heavy rainstorm arrived, "strange noises can be heard throughout the dwelling, and damp spots appear on the wallpaper." Further, on the floor of a second-story room, "a spot of blood comes to the surface," the story related, despite efforts to remove it.

Lumpkin County

THE PHOTOGENIC CEMETERY GHOSTS

Mount Hope Cemetery lies just a few blocks from the historic center of Dahlonega. Its more than one thousand burials include Revolutionary War veterans and recent interees.

Joseph Bealor Moore attended a succession of colleges in the 1920s but only found satisfaction when he arrived at North Georgia College to become a cadet. One night, unable to sleep, he gazed out his dormitory window toward Mount Hope Cemetery. "There he saw a faint greenish white glow that seemed to be rising from the ground," wrote his daughter, Anne Dismukes Amerson, Lumpkin County historian, in the *Dahlonega Nugget*. The curious incident caught his attention, and Moore watched for the phenomenon on other occasions. He soon realized that the green-and-white light appeared exactly at midnight and persisted for several minutes.

Other students also "watched night after night, [as] a figure of a woman became barely visible amid the glowing lights. The ghostly figure seemed to be beckoning toward the campus."

In the late 1940s, Moore told the ghost story many times to his daughter, Anne, and niece, Ydora. He attributed the specter to a young woman, engaged to a North Georgia College student, who died but refused to abandon her lover. She appears nightly to wait for the return of her cadet.

Anne and Ydora pestered Moore until he agreed to show them the ghost. One dark night near Halloween, the three parked across from the cemetery. "I'll never forget that night as long as I live," Anne wrote. They arrived at 11:45 p.m. and anxiously awaited the appearance of the specter. The

Students at North Georgia College have observed a mysterious woman rise from Mount Hope Cemetery. *Earline Miles.*

children hugged each other in fear, secretly hoping that the spirit would not appear. However, at midnight, "Daddy suddenly pointed his finger toward the small knoll across the road. There was a faint glow coming from behind the hill. It shimmered green and white." The frightened girls shut their eyes tight until the light vanished.

The Mount Hope Ghost, known to locals for many years, became one of Georgia's most famous specters in 1953 after a famous photograph was printed in the *Atlanta Journal*.

On April 15, 1953, Madeleine Anthony, local historian and librarian, organized a cleanup of the old cemetery by the Dahlonega Women's Club. The volunteers cleared rubble and trimmed vegetation, and Anthony took a picture to illustrate their work. When the black-and-white photograph of the oldest part of the cemetery, shaded beneath cedar trees, was developed, it showed a thick fog in the center. Most prominent were the head and shoulders of a woman, dressed in period dress. Some who have examined an enlargement of the photo have identified up to twenty different ghostly images—even a bicycle. The ghostly herd seems to approve of the work being done to their resting place. A number of Dahlonega residents have sighted ghosts walking through the cemetery grounds at midnight.

In mid-July 2008, Holly Prince and a team from the Dahlonega Paranormal Investigators ventured to Mount Hope, where she took a series of photographs. She believes one frame depicts the blurry spirit of a girl hovering in front of a headstone, and another shows a hazy adult crossing West Main Street. "That's the first time we've ever taken pictures in the daylight before," Prince said. "When I got home, I downloaded it, and that just popped out—the little girl and the guy in the road."

MADISON COUNTY

THE GHOST IN THE BLUE PICKUP TRUCK

Wayne Ford is my favorite reporter from the Athens area. On November 3, 2010, he presented a unique ghost story for the *Banner-Herald*.

It was around 1980 when Cecil Hart, fifty, a twenty-three-year resident of Danielsville, and his mother encountered a friend. They talked for a while, and then the friend, driving his blue Ford pickup truck, turned south on GA 106 and disappeared in the distance.

After arriving home, which Hart shared with his two sisters, one of the women approached with bad news. The friend was dead, his body at Brown's Funeral Home. "I said, 'No, we just seen him,'" Hart replied. "'We know'd we'd seen him and he spoke to us.' At that time, I did not know that his baby boy was living on the Henry Smith property. I didn't know that. There's where [the] ghost was going. He turned and went south on [GA] 106. He was headed that way."

Hart accepted the fact that his friend was dead and that he and his mother had conversed with him, saying, "He had done right with God, and that's why I know he's still up here riding in that blue Ford pickup truck. I seen him with my own eyes."

Hart's friendship with the man dated back many years. The deceased was considered to be "one of the men that Madison County produced that could do anything." The friend had a reputation as "a jack of all trades. He came up the hard way—he made liquor, done everything to make a living, but he came clean with his God." "I enjoyed going to his house," Hart continued. "He was never mean. Before he claimed to get right with the Lord, he never cussed."

Hart's religious beliefs influenced his interpretation of the bizarre event. "The man and woman that dies lost—you'll never see them again," he declared. "They go down through yonder where they belong." However, those who "died a saved soul and lived their life like the Bible says and…were clean and pure…they stay up here. They don't go nowhere. They stay here. I know that to be so."

Is this why people see ghosts? To this day, that friend might still be tooling down GA 106 in his blue Ford pickup truck.

MILTON COUNTY

THE GHOST OF AN EXTINCT COUNTY

The northern part of Fulton County was originally Milton County. Incorporated in 1857, Milton went bankrupt during the Great Depression and was annexed by Fulton in 1932. Although Roswell was a flourishing community, Alpharetta, formerly New Prospect Campground, became the county seat. Unlike Roswell, few grand antebellum mansions were constructed in Alpharetta, and the town's oldest structure is also its only pre–Civil War building: the Skelton-Teasley House, at 61 Roswell Street. Constructed in 1856 by Dr. Oliver P. Skelton, the red brick Greek Revival building had four large rooms, two on each side of a long central hallway. Stairs led to two small rooms upstairs. The brick walls, forty-eight inches wide at the bottom, narrow to twelve inches at the top.

The building changed hands a number of times. When John G. Willis purchased the house in 1962, he converted it into two duplexes, adding small kitchens and bathrooms to each unit and incorporating modern plumbing and electricity. It was during this time that the house became notorious for its haunting, primarily of the acoustic kind. Doors were heard opening of their own accord before slamming shut. The audio phenomena rousted a number of tenants at night and chased many from their abode.

The house was purchased in 1988 by Dr. David C. and Linda Leonard and renovated for use as an office building. The original flooring, tongue-and-groove heart pine, remains, and two of four mantels were recovered from a chicken coup and reinstalled.

Occupants of the Skelton-Teasley House have heard doors open and slam shut and witnessed invisible fingers manipulate a keyboard. *Earline Miles.*

The Leonards and their employees reported the same activity detected earlier. David once heard the sound of a phantom book being dropped on the floor. Working late one night, he heard the steps of someone walking up the stairs, which had been removed. He decided it was time to leave. "The keys on the keyboard on one of my computers, as well as the fax machine, have been moved by unseen hands," Leonard told Dr. Caroline M. Dillman in 1993 for an issue of *North Georgia Magazine*.

The Leonards believed that the spirits involved are those of four children of Oliver and Caroline Skelton, who died in the house.

Morgan County

YOU CAN'T SLEEP IN THE HAUNTED BEDROOM

Some historic sites do not advertise, acknowledge or comment on their ghosts, but Heritage Hall in Madison is proud to be haunted. Upstairs the master bedroom is boldly labeled "Ghost Bedroom," and a sign hanging outside the door explains the resident specters.

Heritage Hall, also known as the Jones-Turnell-Manley House, was constructed in 1811. The house originally stood two hundred feet away, but in 1909, owner Stephen Turnell sold some of his property, including the site of the house, which was then completely raised off its foundation, placed on logs and moved by teams of horses and mules. The building was Traveler's Inn in 1923, later again becoming a private residence. Mrs. Sue Reid Walton Manley—known as "Madison's First Lady" for her generous support of churches, schools and the community in general—allowed the house to be used for many weddings and other celebrations, a tradition that continues today. At her death in 1977, the heir, a great-granddaughter, donated the house to the Morgan County Historical Society, and it is supported and operated by the Friends of Heritage Hall Inc.

While Dr. William J. Johnston lived here, two of his wives and a child died in the master bedroom. Many believe that one wife, named Virginia, continues to dwell in the room, along with the spirit of her daughter.

One woman who visited Heritage Hall left with a lingering feeling that the Ghost Bedroom was indeed haunted. She returned with a psychic friend, and they asked for some time alone in the bedroom. Afterward, the psychic told a docent, "There is a presence in this room. I see a young girl, and she

A bedroom in Madison's Heritage Hall harbors the ghosts of a mother and servant consoling a dying child. *Jim Miles.*

is dying. Her servant is at the foot of the bed weeping."

On another occasion, a lady had brought a Brownie troop to visit the house. After they left the Ghost Bedroom, the woman told a docent, "As you talked, I could see a girl with dark hair lying in the bed and she was burning up with fever. There was a thin man dressed all in black at the foot of the bed."

One woman refused to enter the Ghost Bedroom, saying, "I am not going to enter this room because I feel there is a presence in there." Another lady once observed a mirror fly off the wall.

Visitors often asked employee Robin Smith about a mother and child they saw perched on a bed. "I don't believe in ghosts," Smith stated, but she had to admit to her own experience. While preparing to leave one night in September 2001, she felt a presence at the top of the stairs. "It sent chills down my spine," she said. Afterward, if she was going to work late, she called in her husband, Rich, a Southern Baptist minister. In the weeks after her experience, two separate women reported paranormal incidents at the same site.

"Part of the reason we call it the Ghost Room is because numerous people have walked in the room and described a strange feeling," stated Ruth Feliks, Heritage Hall's director. "Some visitors say they have actually seen Virginia's ghost lying in the bed," but "the most important reason the name was developed is because there is an etching of a woman on the bottom of the fireplace."

The fireplace floor in that room is thought by many to be a supernatural hot spot. Many believe there is an image there resembling a woman in a long dress, cradling a baby, with another figure, perhaps a servant, crouched at the foot of the bed. Although often cleaned, sanded and repainted, the image always returns.

A photograph of Virginia Nisbet is displayed at Heritage Hall, and former employees have observed her standing at the top of the stairs, where many visitors have felt a presence. Virginia has been known to walk about her former house, even in bright daylight.

One day, Marguerite Copeland, president of the Morgan County Chamber of Commerce, welcomed a married couple into the house. The man and woman entered different downstairs rooms, while Copeland remained between them in the hall. "I could hear the man muttering to himself," Copeland said, but he soon exited the room "and looked rather frightened." He asked where his wife was, and when Copeland explained that she was across the hall, he turned pale, thinking she had been in the room with him. "She was rubbing my shoulders and having a conversation with me," the man explained, but then he had realized that he was alone. The couple "left the house in quite a hurry," Copeland said.

Heritage Hall is open Monday through Saturday from 11:00 a.m. to 4:00 p.m. and on Sunday from 1:30 p.m. to 4:30 p.m. Admission is charged, and tours are narrated by docents. The guides are quite informative, and you are welcome to walk about to examine details that interest you, including the mysterious fireplace. Call ahead to ensure that the date is not reserved for a wedding, reception or party.

Friends of Heritage Hall (madisonheritagehall@yahoo.com) is at 277 South Main Street, Madison, Georgia, 30650. Contact: (706) 342-9627.

Murray County

THE HORRIFYING HOUSE

Dr. L.E. Patterson spent years collecting tales of hauntings from the people of northwest Georgia. His 1982 book, *True Ghost Stories of North Georgia*, retold four stories from Whitfield, Floyd and Murray Counties. Here we relate a Murray County entry, titled "The Horror House."

In 1961, the Mahaffey family moved into a century-old house, originally constructed as a one-room schoolhouse two miles south of Cohutta on Red Clay Road near the Tennessee border. A church had utilized the building, which was eventually partitioned into six small rooms. Water was obtained from a creek seventy-five yards distant, while the bathroom was a five-by-five outside shed forty feet away from the house.

The family consisted of the parents; a twenty-five-year-old daughter, Patsy; a twenty-three-year-old son, Roger; and Bobby, a nine-year-old nephew. The family moved into the tiny, musty house because the rent was cheap. Their only income was the father's social security checks and earnings of Roger and Patsy, both hired hands on a farm.

Things seemed quiet the first night, but at dawn, when the mother got up to prepare breakfast, she found that every can, box and bag in the kitchen pantry had been ripped open and the contents poured out onto the floor. The children cleaned while the parents drove to a store to replenish the larder.

When Bobby returned to the back room that he and Roger shared to dress for the day, he quickly returned to the kitchen and asked, "What happened to our clothes, Roger? They're all over the floor." Each article

of clothing had been taken from the closet and strewn across the floor. The kitchen pantry and that closet seemed to share a ghost that attacked every item each night.

Weeks later, as Roger and Patsy sat up late watching a movie on TV, Patsy glanced into her bedroom and was startled by a sight that she pointed out to her brother. Both watched "a white ghostly form moving slowly" across the bed. Suddenly, the screen on Patsy's bedroom window detached and flew into the living room, narrowly missing the siblings.

Over time, Patsy regained the confidence to sleep in her bed again, and Roger felt secure even though his bedclothes continued to be snatched off every night. Late one night, Roger was awakened by a presence at the side of the bed. It was a boy, about twelve, chubby and wearing antiquated clothing. "Coaches pass on this road every night," the spirit child pronounced. "This place is evil. You must leave!" The ghost then turned and walked several feet before abruptly vanishing.

Roger and Bobby abandoned the room permanently, but a month later, Bobby's parents returned for their son and spent the night in the boy's former bedroom. No one mentioned the previous paranormal experiences to them. The family retired around ten o'clock, with Roger bunking on the couch

In Georgia, residences from the humblest cabin to the grandest mansion are found to harbor paranormal activity. *Earline Miles*.

and Bobby settling onto a pallet on the floor, both pretending that was not where they had slept for the past few weeks. As the guests slept, their blanket was lifted and a ghostly specter loomed over their legs before grasping their ankles in a strong, icy grip. The couple was torn from sleep only to find an elderly man tightly holding their legs. As the woman prepared to scream, the apparition vanished. Bobby and his parents left, never to return.

In the fall and winter, shadow creatures were seen on the move throughout the house. The curtains in that back bedroom were ripped to pieces. Each sleeper had their bedclothes removed in the night, the linen either discarded on the floor or neatly folded and carefully placed in the center of the bed.

One night, Roger was roused by Patsy's scream. Looking into her bedroom, he found her floor six inches deep in cold water. She had stepped out of bed and into the liquid. The water spread throughout the house and across the yard, despite a lack of recent rain or standing water anywhere else, and the house had no water pipes to rupture.

The Mahaffeys moved out and never returned. Over the years, other families rented the cursed dwelling, but none stayed long. Three years later, the structure mysteriously burned down. It is not known whether that was an act of the supernatural residents or frightened human tenants. One former resident, an older woman, said, "Good riddance! It was an evil place!"

Expensive copies of *True Ghost Stories of North Georgia* can occasionally be found online. To consult the book, you may have to find a nearby library that has it in its reference section.

OCONEE COUNTY

THE CHILDREN REMAIN

The Haygood House in Watkinsville, now the Chappelle Gallery, was constructed in 1827. The second owners were Martha and Greene Haygood, who had six children there, including a future president of Emory College at Oxford, one school principal and one early female missionary to China.

Unfortunately, two children, Amelia and Pitt, died in the house in the 1830s, within a year of each other and both at the age of one. The infants were buried in the backyard, although their tombstones were subsequently moved to the front yard. The current owners believe that the graves may be located near a tree in the center of the yard.

The structure is now owned by Kathy and Jerry Chappelle, ceramic artists who purchased the property in 1999 and have renovated it to serve as their home and gallery for different forms of art, produced both locally and from nationally known artisans. "I think people who visit the gallery are impressed by the house just as much as they are awed by the art within it," Kathy said.

The Haygood children seem to remain within their former home, Kathy believes, as she has heard the happy sounds of children laughing and playing. At Christmas. unseen hands play with ornaments on the tree. Just once has she seen something. One day, as she approached the kitchen, she saw a ghostly figure slowly turn a corner to another part of the house. Another time, according to Kathy, "a woman who was staying in the house overnight said she thought she heard a baby crying in the closet."

The spirits of two children who died in Watkinsville's Chappel Gallery linger, happy and mischievous. *Earline Miles.*

While spending the night, one lady felt someone pulling her covers off the end of the bed. "The children love to come and visit, especially at holiday time," Kathy said. "A woman who worked for us told us about some experiences she had, and that was even before we told her about the children. My husband knew by the tone of her voice that she's had an experience with the kids." These ghost children "don't do anything bad, but we related it all back to them." The spirits cause no harm and are welcome in the home.

Chappelle Gallery (http://chappellegallery.com) is at 255 Main Street, Watkinsville, Georgia, 30677. Contact: (706) 310-0985.

Oglethorpe County

FATHER VISITS FROM THE FRONT

Robert Nicodemus Kidd was born in 1832, and the 1850 census had him living in Oglethorpe County. He was an early supporter of the Confederacy, and by the summer of 1861, he was on active military duty in Virginia.

A posting on Rootsweb, an Ancestry.com community, stated, "I don't believe in ghosts but I was once told a ghost story about Robert Kidd." In was early September 1861, when one of Kidd's daughters, either nine-year-old Elizabeth or seven-year-old Hollie, desired to visit friends at a nearby farm. Being so young, the child was accompanied on the trip by an adult servant.

"When they reached the fence," the account read, "the girl screamed and ran back home. When she calmed down enough to talk, she said she had been frightened by seeing her father's ghost. She said she had seen him sitting on the fence post. Not long after, they received word that Robert had died in Virginia."

Kidd had expired in camp near Richmond, Virginia, on September 10, 1861. Some believed that "Robert's ghost stopped by for one last look at his family before passing on."

PAULDING COUNTY

THE GHOST OF THE MURDERED MURDERER

The old Paulding County Courthouse in Dallas was constructed in 1892. Many trials were held there, and many lives were altered. During the 1930s, a local woman was happy to marry an Atlanta man from a prominent family. However, after learning that he belonged to a criminal organization, she tried to leave him. "Her husband ended up murdering his wife in an area between Dallas and Yorkville and cut her body into pieces to the point she could not be identified," said Dale Willbanks, former president of the Paulding County Genealogy and History Research Library, now housed in the former courthouse.

The husband was eventually arrested and brought to Dallas. On the first day of his murder trial, his wife's two brothers intercepted him and killed him on the grounds. Perhaps the spirit of the man is still active in the building.

In 2009, a new courthouse opened, and the research library was allowed to meet in a first-floor room of the otherwise vacant historic building. Almost immediately, members heard footsteps on the second floor. Occasionally, some of the hardier members ventured upstairs to investigate, only to find nothing. When they returned downstairs, the sounds resumed. "What we have heard upstairs in the past, in addition to footsteps, is that of furniture being moved, seemingly across a wooden floor," Willbanks told Neighbor Newspapers on October 28, 2014.

Most peculiar was the fact that the courthouse originally had wooden floors, replaced many years later with concrete. "I believe the old courthouse is haunted," Willbanks concluded. "I believe there are restless spirits in this

place that have some unfinished business here." One time the paranormal sounds were so loud that "I looked up at the ceiling in our room and shouted, 'Go toward the light and your relatives will meet you there.'" As she admitted, "I was just tired of it."

Things were a little quieter afterward, but the sounds are still heard, said new president Patsy Cole. "They even hear footsteps in the daytime." Much of the upstairs is now occupied, and the sounds are less prominent, but the spirit might have developed a new repertoire.

Since the building has central heat and air, the windows are always closed. However, "we sometimes feel cold air come across us even when the room is warm," Willbanks said.

Pickens County

Premonition of a Tragedy

On June 20, 1937, the *Atlanta Journal Sunday Magazine* started a contest, "My Most Weird Experience," which inundated its "Ghost Editor" with a number of experiences. Published on July 4, first place and five dollars went to Alma Gartrell of Whitestone.

In 1928, Gartrell ran a millinery shop on the second floor of the Georgia Marble Company store at Tate, a center of marble production. It was 9:00 a.m. on July 8 when she suddenly heard "an unusual commotion outside." One distinct voice shouted, "Stop the work! Calva Daly will smother to death—he's buried under that load of dust!"

While hurrying to a window, Gartrell thought this was strange, as a succession of heavy rainstorms had turned everything outdoors into a swamp of mud. As she reached the window, the sounds ceased, and all was quiet outside. As she returned to her work, "the voices took up their confused murmur of shouts…all the noise of a panic. Someone was calling for men, for picks and shovels—anything which would move dust fast."

Again, Gartrell hurried to the window, but as she looked out, the hubbub stopped once more. Through the morning, Gartrell would hear the confusion but saw nothing when she looked out the window, for the commotion always suddenly ceased. From "far off toward the mountains, I could hear the sounds of men calling to each other."

At length, the drama closed, as Gartrell heard a man announce, "No use working longer—he's dead. He smothered under that dust before we could dig him out. Somebody go tell his wife and children." Other men called out

the date, July 8, 1929, and the time. Then Gartrell realized it was July 8, 1928, a full year before the phantom events she had heard.

The noise of the workers faded away, replaced by a "wailing, as though a woman and several children were sobbing together, and I heard this sound at intervals all day." Asking around the building, Gartrell learned that no one else had heard the sounds of men, the clashing of tools or the grief.

Gartrell concluded her account: "One year later, on July 8, 1929, Calva Daly lost his life under a load of white stone dust. While he was smothering every detail of my curious vision was repeated—the shouts, the frenzied efforts to save the victim, and the heartbroken sobbing of his wife and children, as I had heard them exactly one year before."

Polk County

NATIVE AMERICAN GUARDIAN

When Jordan was thirteen, his family moved from Pawnee, Oklahoma, to Cedartown. Jordan bitterly opposed the move and redoubled his teen angst and attitude. He distanced himself from his family, but they seemed oblivious to his disaffection.

The rift between Jordan and his parents did not affect him "because I was comforted by this presence, a certain darkness [that] had become familiar to me and it began to manifest itself," Jordan wrote on November 16, 2004, on the Native Ghost Stories website.

The presence had the ability to appear anywhere in the house and was initially able to "disguise its emptiness." It appeared "as a shade or shadow," a darkness that "began to really suck me in," as he drew further apart from his family. One day, Jordan entered his room and "saw a hideously grotesque figure standing in the darkness of my bedroom doorway." He was frozen in place as the entity dissipated.

Jordan attempted to rationalize the apparition as the result of fatigue and headed to the bathroom to shower, but suddenly, "I noticed an unfamiliar stench or smell that accompanied a cool yet chilling breeze." Turning toward the bathroom, he saw that the "shade was now affecting even the areas of the house that were lit, even the well-lit bathroom seemed dim and dull."

Jordan took his shower and went to bed, noting a profound silence in the house. He burrowed deep under his blankets, even covering his eyes, but suddenly "three very frightened cats…all AGRESSIVELY hissing and mewling at this ominous and deep darkness," leaped onto his bed, soaking the covers in urine.

Jordan felt the presence "shrouding my bed and enveloping me and my protective kitties…as this empty and cold presence got closer, I could feel my body being pressed against the bed and the bed being weighed down. I cried out for my mother and just as I felt my breath being stolen from my lungs, she burst through the door and turned on the light. She saw it, the same hideous and frightening 'thing' I saw, but just as the light came on, the presence was gone."

The cats instantly relaxed, and Jordan began crying. His mother "held me tight and asked me if what she saw was real. I explained that it had been coercing me and comforting me up until the recent events."

Jordan bedded down on the sofa in the living room. However, "I peeked over the back of the couch and noticed these silhouettes and shadows of many small children being herded into my room by that disgusting figure. I heard their small feet against the floor."

Jordan attempted to yell for help but found himself "frozen solid and the figure shifted its direct attention right into my eyes and I could feel its horrible and bone chilling eyes glaring into mine. Then it whispered right against my neck and ear, 'Jordan.'"

The presence was ten feet in front of him, but the breath and whispering originated from behind, leading him to conclude that it must be a demon that "wants me." Released from his paralysis, Jordan shouted, and his mother arrived to comfort him again.

Jordan managed to fall asleep but later awoke "to an unstable mother begging for this 'thing' to leave. Then I heard these dreadful footsteps drawing near to us with such power I could feel the floor shaking." The presence stopped above them, and "we could feel this pressure on the sofa around us, then it whispered my name again and vanished."

Jordan's mother also heard the whisper, which "struck a motherly and instinctive cord in her. She immediately stood up and demanded the figure show itself." A creaking was heard from the loft overhead. "My mother opened every door and every window then stood in the center of the house. I remember seeing a warrior inside her, with a big chest and war paint. I still to this day believe her ancestors were called upon. She stomped her right foot and demanded that this darkness leave because the house was hers, not the darkness."

It did depart, but the family soon followed, escaping from the oppressive atmosphere of that cursed house.

RABUN COUNTY

THE GHOST OF TALLULAH FALLS

The first mention of the ghost of Tallulah Falls appeared in an 1891 issue of a Toccoa newspaper. The story published was that those venturing into the gorge had been confronted by a deceased Cherokee who would first frown at intruders and then shoot at them.

The story was reprinted widely, prompting a man to write to the *Chicago Herald* to relate his experience from 1876. He and a friend named Joe were in the canyon when, "suddenly, I saw a man rise to his feet with a very serious look, presenting his deadly rifle at me." As he turned to run back toward their hotel, he shouted at his companion, "Take care of yourself, Joe!"

"The sharp report of a pistol followed my good legs. I cried, I felt the ball hit; I felt the blood run down my back; but had no time to tarry," and he returned to his

The gorge of Tallulah Falls harbors many mysteries, including ghosts, monsters and a vanished race of creatures. *Author's personal collection.*

hotel unscathed. Mystified, the witness described the experience to his host, Mr. Young.

After hearing the tale, the proprietor enjoyed a "hearty laugh" and then explained that he had experienced the ghost of a Native American killed there by a man named Bailey. He said, "That I was not the first one that had flown from there."

ROCKDALE COUNTY

CGPS CASE #112108

A Conyers family was experiencing some supernatural activity in their home. In the master bedroom, the parents reported that something was bumping into their bed, and during the night, an unseen force was pulling at their bedcovers. While in the downstairs living room, their nine-year-old son heard his name being called when no one else was there. One day, the parents were upstairs when they heard footsteps ascending the stairs. Assuming it was their son, they called him but received no reply. They thought he had stopped and gone back downstairs for some reason, but when the father looked, "he reported seeing a 'shadow figure' peek around the corner of the stairway at them, then disappear," Central Georgia Paranormal Society (CGPS) reported.

The mother contacted CGPS to request an investigation of their residence. Seven ghost hunters arrived for a three-hour investigation, from 9:00 p.m. to midnight, bearing infrared (IR) cameras, video recorders, digital still cameras, digital audio recorders and EMF detectors. This research platoon divided into squads that rotated throughout the home.

The team effort garnered only three EVPs, one a male voice growling, "Get out," the other two merely sounds—all inaudible to the investigators in "real time." CGPS detected no "malevolence" during the night, nor had the resident family ever felt such feelings.

CGPS concluded that the house harbored "paranormal activity." The family agreed and planned to keep a log of further supernatural occurrences and contact the society if needed.

STEPHENS COUNTY

A BAND OF GHOSTLY BROTHERS

In 2001, the history book *Band of Brothers* by historian Stephen E. Ambrose and the Steven Spielberg miniseries, produced by Tom Hanks, introduced to America Easy Company, the 506th Regiment, 101st Airborne Division. The regiment was trained at Camp Toccoa, in the shadow of Stephens County's Currahee Mountain, where the men often trained. The paratroopers of Easy Company landed in Normandy early on June 6, 1944, to clear the way for the Allied invasion of France. Then they fought across Europe until the end of World War II, surviving the Battle of the Bulge and liberating concentration camps.

A feature of Toccoa today is the Currahee Military Museum, located within an old train depot where the recruits disembarked before walking five miles to the camp. Inside the depot is a reconstructed horse stable, where the paratroopers were quartered in Aldbourne, England, before D-day. The six-room stable had been dismantled, secured to pallets by the Royal Air Force, flown to Dobbins Air Force Base in Marietta by a C-17 of the Mississippi Air National Guard in October 2005, trucked to Toccoa and rebuilt within the old depot. The museum, which opened in March 2006, also houses the Stephens County Historical Society, the Stephens County History Museum, the welcome center and the chamber of commerce.

The museum had not been open long when volunteer workers reported hearing footsteps in empty spaces, sudden cold breezes without accountable sources and anomalies on photographs.

An American paratrooper company lived in this English barn before invading France at Normandy; one lingers today to protect their storied legacy. *Earline Miles*.

On February 3, 2007, Bev Greenfield led five other members of the Foundation for Paranormal Research (FPR) to conduct an investigation of the museum. En route, Ken Summer received a revelation: he would find a name carved on the wall of the stable. At the museum, Summer was immediately confronted by a dramatic scene: the ghosts of four young men clothed in World War II uniforms and helmets.

As the team entered, one member felt a tingling in her lips, which indicated the presence of spirits, and two felt tingling at a certain location inside the museum. Four members experienced sharp pains in their left arms, just below the shoulder. One felt a presence tug on a camera strap hung over her left shoulder. Summer felt a cold chill on his left shoulder, which he believed was a spirit guiding him through the museum. He asked a volunteer worker about a carved name on a wall and was told there was one. Summer found it, but the name was not right. With a flashlight, Summer made a close inspection of the walls in the third stable room and found a name no one had noticed before: "Davie."

"This was it!" Summer wrote. "There was no denying that this was the message from my 'guide.'"

Summer believed that the individual was David Morris, who died in 1999. He believed that Davis had injured his left shoulder in a parachute jump and that the spirit of the soldier has taken up residence there to act as a guide for the history of his unit.

The Currahee Military Museum (http://www.toccoahistory.com) is open from Monday to Saturday 10:00 a.m. to 4:00 p.m. and Sunday 1:00 p.m. to 4:00 p.m. at 160 North Alexander Street, Toccoa, Georgia, 30577. Contact: (706) 282-5055.

Towns County

THE FRIENDLY GHOST ON FROG POND ROAD

In 2007, a woman identified as "Legendsofgreenisle" left an abusive relationship and for the first time in her life lived independently, along with her two daughters and son. She was delighted to rent a three-bedroom house located on Frog Pond Road in Hiwassee for a reasonable rate.

The old red brick building, in an established part of town, had been constructed by Mr. and Mrs. B, whose family had owned the property for ninety years. After Mr. B died in the house, Mrs. B moved down the road to a larger house built by her son.

Moving in gave the woman some relief from her previous problems, but soon, "I felt a nagging feeling of fear and my nightmares increased," she reported on the website of the Northeast Georgia Paranormal Society (NGPS). Two weeks after moving in, "I woke up one night to a terrifying dream of the man who I had left, being under my bed and reaching up to choke me." She allowed her racing heart time to subside, but that wasn't the end of her terror for the night.

She described herself as a psychic and sometimes saw "the dark shadows or things which give us nightmares, and they're not pleasant." During this time, she "was being haunted by a little four foot elemental [earth spirit]. He had yellow eyes, shaggy, curly hair all over his body, and two ram looking horns protruding from his head." She considered this creature odd because it wore a velvet vest and pants, as if it "was his attempt to be human." She feared it was present as a result of "my stupidity in my younger days when I meddled with spells."

As the woman started to drift back to sleep, the frightening elemental "popped up beside the bed and gave me another jolt of adrenaline." An unexpected development occurred as "Mr. B suddenly appeared out of nowhere, with a white handkerchief over his nose, and beat at the elemental until he vanished just as quickly as he appeared. I guess even in the spirit world some things just smell bad."

The elemental had "fed off my pain and misery," but she later learned to "embrace joy, peace and love" and repulsed the creature "with a mental picture of a large gold bubble around my two acres." She also told the being that he wasn't welcome.

The woman believed that Mr. B "kept constant vigil the year we stayed in that house. I'd hear the back and front door knobs rattle as he checked the locks on a nightly basis." During this time, the family found "contentment and joy again."

A woman fought a paranormal entity called an elemental in her house on Frog Pond Road, assisted by a dead former owner of the property. *Earline Miles*.

UNION COUNTY

THE SPIRITS AT TRACK ROCK GAP

One of Georgia's most intriguing archaeological sites is found at Track Rock Gap. At some distant time, Native Americans carved representations of prints—human and animal—into a series of boulders. Cherokee legend claims that after a worldwide flood, surviving creatures stepped from a great ship to the ground there. Although extensively vandalized, the surviving tracks remain along Track Rock Gap Road.

Not far from the ancient petroglyphs was the Jack Ensley House. Perhaps to imitate or placate the prehistoric inhabitants, Ensley crafted wooden representations of his family member's footprints and nailed them to the outside walls of the house. Their outlines were visible for many years.

A longtime resident of that area was Jewell Dyer, who told reporter Bob Harrell for the October 31, 1978 edition of the *Atlanta Constitution*, "I don't know that anybody ever lived here long. Them that did always had some tale to tell about the house."

Dyer described the experiences of a former resident, Otis Nixon, who "told me that at night he could hear walking upstairs. And sometimes he heard groaning, too."

Yet another resident was Charles Plott, who "used to say he could hear water dropping on the roof at night."

"Was that bad?" Harrell asked.

"It was if the sky was clear," was the reply.

One day, Dyer escorted two enterprising reporters to the house. As he opened the front door, the door into the next room slowly swung open with

Left: According to Cherokee tradition, ancient Native Americans left their tracks on boulders following a flood. *From James Mooney's* Myths of the Cherokee.

Below: Georgia's prehistoric inhabitants had a rich mythology involving all manner of supernatural beings. *Jim Miles.*

creaking hinges. "It's my weight on the floor. That's why the door opened," Dyer explained, but he found only one reporter still with him. The second was standing in the yard, basking in the bright sunshine.

WALKER COUNTY

HAUNTED LOOKOUT MOUNTAIN

On the Cutting Edge website on October 31, 2012, Martin Luther, Vampire Hunter (MLVH), described a holiday at Covenant College, perched high atop Lookout Mountain. It was Day of Prayer (they had two a year, which students referred to as "Day of Dollar Movies" or "Day of Smoking Cloves in the Woods"), when he went hiking in the woods, seeking a rumored waterfall on the mountain. Three hours later, he was lost, but that wasn't his biggest problem.

Suddenly, "a cacophony of loud barking erupted behind me." Twirling around, he found "barreling through the trees at me were two black Rottweilers," foaming at the mouth. MLVH ran and encountered the ragged edge of the mountain (people paraglide off Lookout Mountain), with a narrow ledge a foot and a half wide. He stepped onto the ledge, thwarting the dogs. He ledge walked around the dogs and descended the ridge.

MLVH came to a valley filled with sunflowers the height of corn. He started through the colorful vegetation and was surprised when "ten feet in front of me, emerged a girl," mid- to late teens, pale, dark eyes and hair, "and her clothes were frilly, black, and neo-Victorian," Goth-like.

After he said hello, he said the girl "glared at me with the awful, hateful gaze…sheer loathing." He did not approach the girl, circling around her and enduring "her awful, awful gaze, like I was an invader."

Six hours after starting the hike, he emerged at Rock City and returned to campus, grateful to be home. One month later, MLVH was talking to a friend, who described a hike he and a friend had taken on the mountain

Students from Covenant College have encountered ghosts on campus and across Lookout Mountain. *Earline Miles.*

during the summer. In a field, they found an unoccupied two-room house. Looking through the screen door, they found the interior decorated with magical symbols and "small, hanging bones." They were shocked when "out of nowhere, from around the side of the house emerged two black Rottweilers who chased them away." Such dogs are a regular part of supernatural events.

WALTON COUNTY

HAVE YOU SEEN "HER"?

Social Circle is a grand old southern town that boasts of its hospitality (hence the name) and its beautiful Victorian houses. In 1995, Dee and Kemal Joseph purchased one of these homes for their family. It had been built circa 1860 by Dr. Joseph Brown and occupied by a succession of Walton County families.

The house needed extensive renovations, including refinishing floors, plastering and wallpapering; remodeling bathrooms; and many other projects. After eight months of exhaustive work, the house was finally ready for the Joseph family. As the couple had worked, they got to know their neighbors, and occasionally one would ask with a mischievous grin, "Have you seen 'her'?"

Neighbors explained that "she" was a ghost, sighted often in the halls and on the stairs of the house. She wore a full hoop skirt, with her hair neatly tied in a bun. She liked watching children at play and had been at these activities for half a century or more.

Son Matt Joseph was the first to spot her. Alone in the house one evening, he was in the downstairs living room watching television when he spotted her walking up the stairs. When his parents returned, Matt asked, "Is this house haunted?"

"Yes, we have heard there is something here," Dee replied. "Why, have you seen her?" On a different night, Matt was relaxing on his bed when the Victorian woman appeared at his doorway, looked at him, and walked away.

Social Circle has a number of haunted houses. Many residents have asked the owners of an 1860 home, "Have you seen 'her'?" *Earline Miles*.

Dee collapsed in the den one day after work and saw her glancing around a doorway, as she related to Melanie Jackson of the *Walton Tribune*. The spirit peeked at Dee and then dematerialized. The Josephs did not fear the ghost and welcomed her into their home. "Yes," they told neighbors. "We have seen 'her.'"

WHITE COUNTY

THE NACOOCHEE VALLEY GHOST

In 1985, Hamilton Schwartz, a native of Pennsylvania then thirty-six years old, was a graduate of Georgia Tech with a career in health engineering. He and his wife, Kathy, lived and worked in Atlanta, but they dreamed of starting a business together later in their lives. Within a year, after staying in several country inns in New England, they quit their jobs, found a "how to start your own rustic bed-and-breakfast inn" guide and started a search for a suitable property.

In White County's beautiful Nacoochee Valley, just outside the tourist community of Helen, they located the Stovall Inn, a 172-year-old Victorian named for the family who occupied it from 1893 until the late 1940s. "The moment we found this place and saw the view from the porch," Schwartz told Randolph Floyd for the October 27, 1985 edition of the *Atlanta Constitution*, "we were hooked; it felt just right." They purchased the house in 1982, and two years later, it was added to the National Register of Historic Places. The Schwartzes added modern bathrooms and plumbing and renovated the second floor, furnishing it with period furniture retrieved from the attics of Schwartz family members in Pennsylvania.

As they worked, locals stopped by to warn of the ghosts that inhabited not only the house but the grounds as well. "The original owner of this house, Moses Harshaw, was reputed to be the meanest man who ever lived," Schwartz stated. "His daughter died while still a teenager and is buried on the property somewhere around here." The child's spirit was known to stalk the grounds at night, calling out for her mother.

The Stovall House is visited by the ghost of a girl that wanders the property crying, "Mama, Mama." *Earline Miles.*

Schwartz's first paranormal experience at the Stovall House occurred while he and several carpenters worked late at night. At one point, they heard a girl's voice from outside, plainly and repeatedly saying, "Mama, Mama." "It had been a long day," Schwartz said. "And we were tired. But we heard that sound and looked out the window. Nothing was there, so we went downstairs to investigate. There was nothing there either, and I haven't heard that sound since."

Once the couple occupied the house, Hamilton awaited his first ghostly encounter within the structure. One night, around 2:00 a.m., as he slept alone in a first-floor bedroom, he heard slow, heavy footfalls descending the stairs from the second level to the first. "They sounded so real, I went outside to investigate," Schwartz related. "There was nothing there—but it definitely wasn't a dream." "It was just weird," he recalled, but certainly not surprising or even frightening, saying he "had been expecting something like that."

Suzanne Fain, a cook and waitress, sometimes felt a spirit enter a room. "But there's nothing to be afraid of," she said. "It's a good spirit. You can feel it."

Guests reported rattling doorknobs, phantom footsteps and moaning from the halls at night. Cold, clammy spots were also a regular phenomenon. "I

believe in ghosts—at least in the aspect that people appear to have sensed them, including myself," Schwartz said.

The Stovall House is still a bed-and-breakfast. Floyd Summer is the current proprietor. The Stovall House (stovallhousebnb.com) is located at 1526 Highway 255 North, Sautee, Georgia, 30571. Contact: 706-206-9581.

WHITFIELD COUNTY

THE WINK, A HAUNTED THEATER

Living drama queens and kings dominate local theaters, emoting strong feelings, and it seems that old thespians do not fade completely away. Nearly every theater in America seems to be haunted.

J.C. Wink constructed the Wink Theater on West Crawford Street in downtown Dalton in 1938. It was the city's first air-conditioned structure, featuring a removable screen for live performances. Unfortunately, during construction, or so legend holds, a man was killed and buried on the property.

Leon Hurst brought his family to Dalton in 1971 to manage the theater and renovated it the following year. Leon heard unusual sounds during the remodeling, particularly ghostly footsteps on the stairs when he was alone. One evening, he had locked the theater and went to work in his upstairs office, which is adjacent to the lobby. An old staircase extended from the street past the lobby to the balcony—the entrance black patrons were required to use before integration. As Leon worked, he distinctly heard large metal canisters, used to store the huge rolls of projection film, bumping down the stairs. His investigation revealed nothing.

Leon's son, Dale, started working at the Wink at an early age. With two college degrees, he announced, "I consider myself to be pretty well educated and scientifically oriented." An issue like ghosts had to be proven to him. After working there for years, he changed his tune, telling writer Connie Hall-Scott, author of *Haunted Dalton Georgia*, "I think anybody who goes inside that theater, whether you believe in ghosts or not, will sense a presence."

Paranormal activity at Confederate cemeteries is frequently reported, including at Dalton's West Hill Cemetery. *Jim Miles.*

One summer afternoon Dale was working the projection booth, which meant starting a new reel every twenty minutes. After one exchange, he strolled out to watch the movie. Suddenly, from within the projection room came sounds like someone had picked up the metal stool there "and started beating the walls with it." The noise was loud and frightening, the more so because no one could have gotten past Dale and into the booth.

Late one night, Dale was cleaning the theater, sweeping the long aisles. His back was to the seats as he worked to music he had turned on. Abruptly, the music dropped in volume, and he heard someone approaching from behind. "It sounded like a tall guy with about a size 15 shoe, running so clumsily that his feet slapped the floor as he ran." Dale awaited an assault, but the footsteps stopped and the music resumed its normal level. Turning at last, he saw nothing.

Dale said that his father would hear children, with bells on their shoes, playing outside his office. More startling was how as he worked the doorknob to the office would turn, and an unseen entity would make an impression on the leather seat across from his chair.

When the Wink was threatened with demolition for a parking garage, Troy Hall purchased and renovated the theater. His daughter, Connie Hall-Scott,

Ghosts at the Wink Theater slam film canisters around, beat on the walls and occasionally stroll the aisles. *Earline Miles.*

once director of the Wink, wrote an article about hauntings at the facility for *Fate* magazine's October 2005 edition. "The most bizarre thing happened," volunteer Jennifer Rushing told Scott. "I saw a dark shape pass by me and then the film began shooting from the reels for no apparent reason at all. I was scared, but I forced myself to finish up."

Handyman Isidro Esparza was hammering nails into an upstairs storage room when he laid down the hammer to drink some water. "That's when the hammering started back," he said, "only I wasn't doing it. Nobody was doing it. I listened and tried to figure it out. It kept going but I couldn't figure it out."

That tale was backed up by an article that appeared in the April 16, 1980 issue of the *Daily Citizen News*, titled "Child Lives at the Wink." Leon Hurst told reporter Neely Young that as he worked one early Sunday afternoon, "I began to hear a hammering sound" that "sounded like someone beating walls with a hammer." He checked the area for construction activity but found he was alone on the block. The noise continued for ten minutes "and happened for two consecutive Sunday afternoons," each time lasting ten minutes.

Many workers and patrons speak of "the lady in the bathroom." The women's upstairs restroom often harbors a cold spot and feelings of unease. Connie personally felt the latter as she stood before a mirror.

In July 2003, Connie occupied a stall in the restroom when she heard a flush from another toilet. She had thought she was alone and said, "Hello," but there was no response. Finished with her business, she opened each stall door but found no one. As she finished her inspection, a toilet flushed itself.

While custodians work in the bathroom, toilets flush, stall doors open and close and the position of toilet seats are changed, up to down or down to up.

Repeated visits by the Foundation for Paranormal Research captured orbs of various sizes at the stage, projection room and basement, and a female voice on an EVP says, perhaps with wry movie humor, "I see people." Using a psychic and dowsing rods, they determined that the theater harbored eight different ghosts.

The Wink hosts numerous events. It is located at 114 West Crawford Street, Dalton, Georgia, 30720.

WILKES COUNTY

A HUNTING CAMP STORY

A man identified by the name "IslandD" related a ghostly incident he experienced while at a hunting camp near Tignall in 1986. He explained that he was a lifelong southerner, born to the outdoors and an avid hunter and fisherman. He and friends were at the camp when he spotted what seemed an ideal site, an area clear cut of trees several years earlier but now thick with undergrowth. He described the situation to his companions, but they informed him that they had hunted that area without success.

Undeterred, the man drove his pickup down a service road to the end of the cut trees. He picked up his rifle and portable deer stand and set out to find a suitable tree. Along the way, he passed an old homesite, marked by foundation stones and a chimney. The hunter climbed a tree and waited patiently for hours, but no game appeared. Glancing at the chimney, he saw a man in a dark jacket glaring up at him. Fearing he might have trespassed on land not leased by the hunting club, he waved but was ignored. He then climbed down to speak to the man, but the figure had disappeared.

Back in the tree, he spotted the man again. This time he yelled, but again there was no response. He used his scope to examine the figure, seeing that he had a beard and wore plain pants and jacket. Returning to the homesite, he examined the ground, finding no footprints but his own.

Thinking that his friends were playing a prank and a little frightened at the thought that they *weren't*, he returned to the tree for his stand, prepared to vacate the odd place. Back in the tree, he saw that the man had returned. Irritated and disturbed, he hoisted his 30.06 and fired a shot

A group of Confederate horsemen thought to be escorting a lost treasure have been encountered at the Callaway Plantation. *Earline Miles.*

over the man's head. The man did not flinch, nor did he react to another round fired at his feet.

The man hurried to his truck and started down the road, wondering why he had not seen "any sign of deer, rabbit, squirrel" or anything else. At the main road, he spotted an elderly man tending his garden and stopped to ask about the land he had just left.

"Ain't nothing live down that road but trees," he was assured. During the Civil War, a stranger had appeared and killed an entire family there. The murderer was never brought to justice. The older man concluded that "it was a waste of time to hunt anything down in those woods." The man packed up and drove straight home. Occasionally, "I have a dream where I am up in that tree and the Man walks up to the tree. I wake up scared as a baby."

BIBLIOGRAPHY

Akien, Matt. "Searching for Dahlonega's Haunt Spots." *Dahlonega Nugget*, July 16, 2008.
Albea, Alice Guillebeau. "Ghosts I Have Met." *Atlanta Journal*, November 19, 1933.
Amerson, Anne Dismukes. *Dahlonega's Historic Public Square*. Dahlonega, GA: Chestatee Publications, 2002.
Arrington, Julie. "Resident Share Stories of Ghosts, Mysteries." *Forsyth County News*, October 31, 2010.
Athens Banner-Herald. "Ghostly Apparitions Await the Folks on the Haunted Tour." October 12, 2005.
Atlanta Journal-Constitution. "Haunted: Family Says Spirits Shielded Them in Storm." February 27, 2006.
Baldowski, Bill. "A Haunting Question: Locals Wonder if Old Courthouse Has Ghosts." *Neighbor Newspapers*, October 28, 2014.
Barber, Christina A. *Spirits of Georgia's Southern Crescent*. Atglen, PA: Schiffer Publishing, 2008.
Barrow County Ghostbusters Investigations. "Private Residence in Auburn, Ga, Case #07-001."
Bates, Ashley. "The Ghost in the Library." *Gainesville Times*, October 25, 2009.
Blackmarr, Amy, and R. Brian Keith. *Dahlonega Haunts: Ghostly Adventures in a Georgia Mountain Town*. Tifton, GA: Willacoochee Pub., 2005.

Bibliography

Boone, Christian. "Ghost Luster Lost." *Atlanta Journal-Constitution*, January 22, 2007.

Burchill, James V. *The Cold, Cold Hand: More Stories of Ghosts and Haunts from the Appalachian Foothills*. Nashville, TN: Rutledge Hill Press, 1997.

Central Georgia Paranormal Society. "Case #112108: Residence, Conyers, Georgia."

Christian, Reese. *Ghosts of Atlanta: Phantoms of the Phoenix City*. Charleston, SC: The History Press, 2008.

Dillman, Caroline. "The Skelton-Teasley House." *North Georgia Journal*, n.d.

Dismukes Amerson, Anne. "Glaze Recalls Seeing Ghost at Mt. Hope." *Dahlonega Nugget*, n.d.

Dolgner, Beth. *Georgia Specters and Spooks*. Atglen, PA: Schiffer Publishing, 2009.

Dunwoody Crier. "A Dunwoody Ghost Story." November 2, 2010.

Emerson, Bo. "Familiar Haunts." *Atlanta Journal-Constitution*, October 30, 1983.

Explore Southern History. "Tallulah Gorge and Falls, Georgia." exploresouthernhistory.com.

Fielding, Ashley. "Spook Searches: Ghost Hunters Comb Library for 'Miss Elizabeth.'" *Gainesville Times*, September 15, 2007.

Floyd, Randall E. "Inn Has Occasional Visits from Guest Who Rattles Doors and Often Moans." *Atlanta Journal-Constitution*, October 27, 1985.

Ford, Wayne. "Man Has Doozy of a Ghost Story." *Athens Banner-Herald*, November 3, 2010.

Forgotten USA. "Haunted Braselton Town Hall."

Fults, Mark E. *Chattanooga Chills*. N.p.: CreateSpace Independent Publishing Platform, 2012.

Gartrell, Alma. "When Tragedy Held a Rehearsal." *Atlanta Journal*, July 4, 1937, *Sunday Magazine* section.

Ghosts of Georgia Paranormal Investigations. "Restaurant, Trenton Ga. 10-02-10."

Goodson, Edith, and Willette Mote. *White Tales from Hollingsworth*. Clayton, GA: Fern Creek Press, 1998.

Gordon, Mrs. Robert. "The Pink Lady." *Atlanta Journal*, December 28, 1947, *Sunday Magazine* section.

Greenfield, Bev. "Band of Brothers: The Currahee Military Museum." The Foundation for Paranormal Research.

Guillebau, Alice. "Old House Is Weather Prophet." *Atlanta Journal*, November 19, 1933, *Sunday Magazine* section.

Bibliography

Haeli. "Tallapoosa, Georgia Ghost Sightings." Ghosts of America.
Hall, Kristi. "Haunted Hot Spots." *Lakeside Magazine* (Fall 2008).
Hall-Scott, Connie. "Child Lives at the Wink." *Daily Citizen*, April 16, 1980.
———. *Haunted Dalton Georgia*. Charleston, SC: The History Press, 2013.
Heritage Hall. "Ghost Bedroom." Sign posted, Madison, Georgia.
"IslandD." "Hunting Camp." Your Ghost Stories, January 5, 2009.
Jackson, Melanie. "Have You Seen Her?" *Walton Tribune*, n.d.
Jacobs, Jeanette. "Strange Happenings at Fort Hollingsworth." *Athens Magazine* (April 1, 2002).
Jones, Jennifer. "Inns Spooky Activity Will Make Visit Memorable." *Anderson Independent-Mail*, October 19, 2005.
Jordan. "2256 Jordan-Cherokee-Cedartown GA." Native Ghost Stories, November 16, 2013.
Koenig, Blair. "Hauntings: The Ghosts and Spirits of Watkinsville." *Southern Distinction*, October 1, 2004.
Lair, Layla. "Corpsewood Manor: Haunted Ruins in Northwest Georgia." *Bubblews*, October 31, 2014.
"Legendsofgreenisle." "True Ghost Story: The House on Frog Pond Road." Northeast Georgia Paranormal Society. July 2, 2013.
Luther, Martin, Vampire Killer. *The Cutting Ledge*, blog.
Martin, Anva, and Duana Callahan. "The Houses that Haunt Atlanta." *Signaanyal's Tuesday Magazine* (October 30, 2001).
Miles, Jim. *Civil War Ghosts of North Georgia*. Charleston, SC: The History Press, 2013.
Mooney, James. *Myths of the Cherokee*. New York: Dover Publications, 1995.
Murder at Corpsewood: The Saga of Chattooga County's "Devil-Worshiper Slayings." Summerville, GA: Espy Pub., 1983.
Newnan Herald. "Are We Visited by Angels?" July 12, 1872.
Patterson, L.E. *True Ghost Stories of North Georgia*. N.p., n.d.
Pierce, Katherine. "Georgia Ghost Predicted Attack on Pearl Harbor." *Atlanta Journal-Constitution*, December 2, 1950, *Sunday Magazine* section.
Pittman, George. "Visions of the Past." *Atlanta Journal Constitution*, May 20, 1984.
Rachel, R. "You're Smiling in Corpsewood!" AngelFire, November 1, 2002.
Roberts, Nancy. *Georgia Ghosts*. Winston-Salem, NC: John F. Blair, Publisher, 1997.
Ronner, John. "'George' Haunts House." *Rome News-Tribune*, October 31, 1975.
Rootsweb/Ancestry.com. "Nicodemus Robert Kidd." rootsweb.ancestry.com.

Bibliography

Sami, Jennifer. "Going Backstage in the Hunt for Ghosts at Tam's." *Forsyth County News*, October 28, 2007.

Savannah Morning News. Gwinnett County ghost. February 28, 1889.

———. "Outhouse Ghost." March 15, 1892.

Scudder, Charles. "A Castle in the Country." *Mother Earth News*, April 1, 1981.

The Shadowlands. "Battlefield Ghost." http://theshadowlands.net/ghost/ghost273.html.

Smith, Gordon Burns, and Anna Habersham Wright Smith. *Ghost Dances and Shadow Pantomimes: Eyewitness Accounts of the Supernatural from Old Georgia*. Milledgeville, GA: Boyd Pub., 2004.

Smith, Kandice. "A 'Spirited' Place to Be: Lavonia's Southern Oaks." *Franklin County Citizen*, October 25, 2007.

Stanley, Lawrence L. *Ghost Stories from the Southern Mountains*. N.p., 1971.

Stepp, Dianne. "When Conditions Are Right, There Are Ghosts in the Night." *Atlanta Journal-Constitution*, October 31, 1985.

Straus, Hal. "Devil-Worshipers Captured County's Imagination." *Atlanta Constitution*, December 22, 1982.

Stringer, Sandra. "Ghostly Mysteries." *Gainesville Times*, October 30, 1994.

Summers, Ken. *Queer Hauntings: True Tales of Gay & Lesbian Ghosts*. Maple Shade, NJ: Lethe Press, 2009.

———. "Queer Paranormal Road Trip: Corpsewood Manor." *Spooked!*, May 1, 2008.

Testament, Kerri. "Town Hall Marks 100th Anniversary." *Braselton News Today*, April 12, 2009.

Wells, Jeffery. "The Historic Green Manor in Union City." *Georgia Mysteries*, blog, March 5, 2009.

Wilcox, Herbert. "Watchman Ok's 3 Ghosts." *Atlanta Journal*, September 11, 1938, *Sunday Magazine* section.

Wilkie, Leisa J. *Haunting History of Canton*. N.p.: Yawn's Books & More, 2013.

Wilson, Mary. "Habersham County Stone Circle." Interview by author, 1978.

Yeomans, Curt. "My Life Working with a Civil War Ghost." *Henry-Herald*, August 28, 2014.

Yoo, Charles. "DeKalb Buys House in Ghostly Condition." *Atlanta Journal-Constitution*, February 27, 2006.

ABOUT THE AUTHOR

Jim Miles is author of seven books of the Civil War Explorer Series (*Fields of Glory, To the Sea, Piercing the Heartland, Paths to Victory, A River Unvexed, Forged in Fire* and *The Storm Tide*), *Civil War Sites in Georgia* and two books titled *Weird Georgia*. Five books were featured by the History Book Club, and he has been historical adviser to several History Channel shows. He has also written seven books about Georgia ghosts: *Civil War Ghosts of North Georgia, Civil War Ghosts of Atlanta, Civil War Ghosts of Central Georgia and Savannah, Haunted North Georgia, Haunted Central Georgia, Haunted South Georgia* and *Mysteries of Georgia's Military Bases: Ghosts, UFOs, and Bigfoot*. He has a bachelor's degree in history and a Master of Education degree from Georgia Southwestern State University in Americus. He taught high school American history for thirty-one years. Over a span of forty years, Jim has logged tens of thousands of miles exploring every nook and cranny in Georgia, as well as Civil War sites throughout the country. He lives in Warner Robins, Georgia, with his wife, Earline.

*Visit us at
www.historypress.net*

This title is also available as an e-book